Beginner's Guide to
Enamelling

Dedication
*To all the members of the Guild of Enamellers from whom I
have learned so much over the years.*

Beginner's Guide to
Enamelling

Dorothy Cockrell

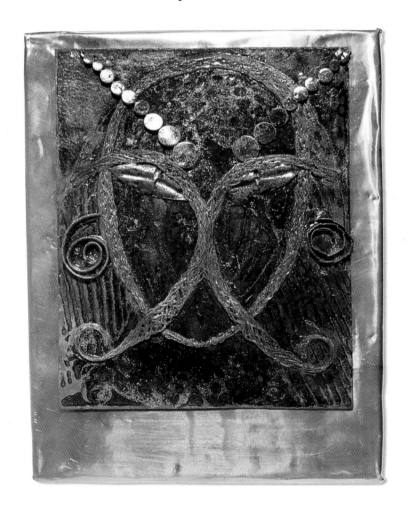

SEARCH PRESS

First published in Great Britain 2004

Search Press Limited
Wellwood, North Farm Road,
Tunbridge Wells, Kent TN2 3DR

Text copyright © Dorothy Cockrell 2004

Photographs by Charlotte de la Bédoyère, Search Press Studios
and by Roddy Paine Photographic Studios

Photographs and design copyright © Search Press Ltd, 2004

ISBN 1 903975 61 1

The Publishers and author can accept no responsibility for any
consequences arising from the information, advice or instructions
given in this publication.

Suppliers
If you have difficulty in obtaining any of the materials and
equipment mentioned in this book, please visit the Search Press
website for details of suppliers: www.searchpress.com

Alternatively, you can write to the Publishers at the address
above, for a current list of stockists, including firms which operate
a mail-order service.

Publishers' note

All the step-by-step photographs in this book feature the
author, Dorothy Cockrell, demonstrating enamelling. No
models have been used.

Acknowledgements

*With thanks to Robert Eves, Marion and Stan Fray,
Veronica Matthew, Harry Nicholson,
Janet Notman, Betty Stuart, Kathleen Kay and
May Yarker for making and/or lending work to
help illustrate various processes.*

Page 1
*A clock carved and made by Robert Eves, with an enamelled face
by Dorothy Cockrell.*

Page 3
Warrior Midge

*This piece was inspired by an electron microscope image of a
midge which I thought resembled the mask found at the burial
site of an Anglo-Saxon king at Sutton Hoo in Suffolk. Liquid
and sifted flux were used with the sgraffito technique. Copper
wire and small copper discs were fired into the enamel, then
raku fired. Small pieces of dichroic glass were glued in for eyes.*

Page 5
Model Girls

*The figures and flowers were stencilled in transparent black
enamel over a fired layer of flux. After the black enamel was
fired, the dresses were cut from gold foil, laid in place and gum
solution fed in at one end. It spread under the foil, making it lie
flat. The piece was left overnight to dry before firing. Foil does
not expand and contract in the kiln in quite the same way as
the enamel; this gives a textured surface that reflects light well
and is most noticeable with larger pieces of foil.*

Contents

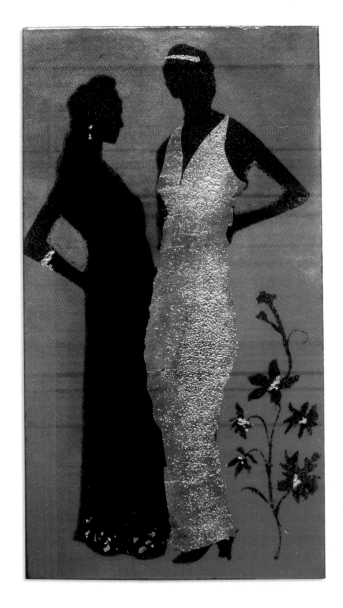

Introduction

Enamelling seems very close to magic, but the basic technique is as simple as making toast: powdered glass is sifted onto a piece of copper, melted for a few moments in a small kiln and cooled, and it then glows with permanent colour. The colours produced can be vivid or subtle, plain or shaded, light or dark, just as you choose. Unlike paints they do not fade with time, so your work will last for a very long time. Enamelled objects from Roman times and even earlier are still to be seen.

You can make enamelled jewellery, pictures, tiles, decorations, bowls and many other items. It is not necessary to be a great artist (although such skill is always an advantage); a careful craftsperson can produce really attractive pieces that will delight their maker and find a ready market.

For all the projects in this book I have used readily available pre-cut copper shapes. Anyone with metalworking skills can, of course, cut and shape their own pieces from copper sheet. Copper is the best metal to use when you are learning as it does not melt as silver can, so you can concentrate on melting the glass enamel without worrying about the metal under it.

The projects follow each other in a logical sequence, building from the basic method to more advanced and experimental techniques. Many of these techniques can be combined, allowing you to design truly individual pieces.

A kiln is the most expensive piece of equipment that you will need; most of the rest can be found around the house or made from 'free' materials. Wherever possible, I have suggested inexpensive methods.

Many enamellers work in the garden shed, garage or spare room. Enamelling can be done on the end of the kitchen table with the kiln sitting on top of the stove. Just remember that enamel is powdered glass, so it is not advisable to cook dinner at the same time. Always follow the safety advice on page 12.

Enamellers are usually eager to share their expertise. I would advise you to join an enamelling guild, even if it is not near your home area. Many of them publish newsletters or journals, have web sites, run courses, have demonstrations and hold exhibitions. Information about them and other enamelling matters is easily found on the internet.

All the projects in this book have been made with pre-cut copper blanks, but if you have metalworking skills, you can produce spectacular individual pieces of your own design.

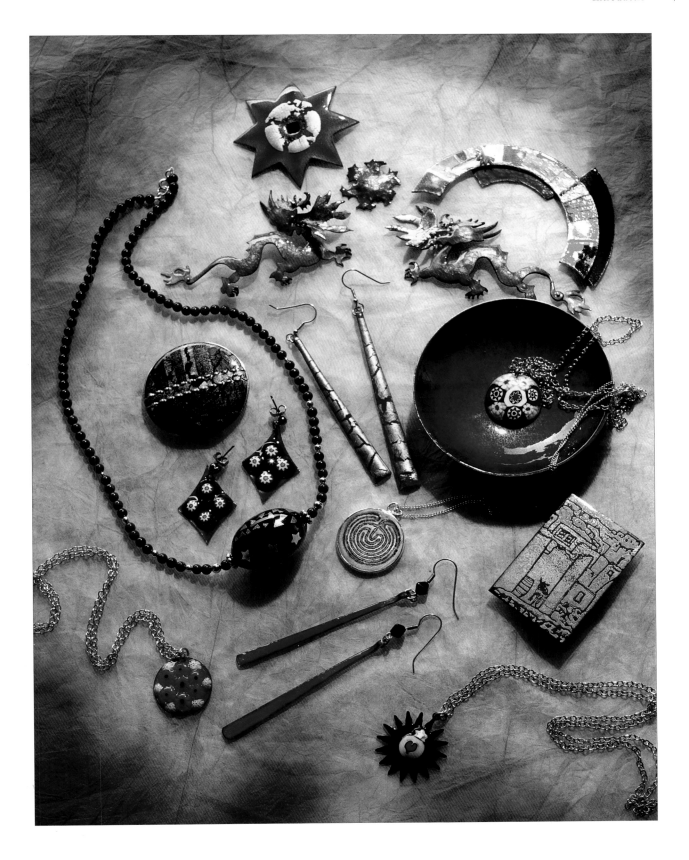

Tools and equipment

All the items on this list can be purchased, but wherever possible I have suggested 'free' alternatives.

Basic set of enamels

Enamels are mainly of two types, opaque or transparent and are sold in powder or liquid form. You can buy leaded (they contain lead) or unleaded enamels. Leaded enamels have the widest range of colours, but for children, unleaded ones are recommended.

Powder enamels

Essentials in powder form are: clear, colourless copper flux; the three primary colours plus black and white in opaque enamel; medium transparent blue to make greens and perhaps dark transparent purple to alter opaque blue and red. White liquid enamel (shown left) is used for some of the projects in this book. Try to resist the temptation to buy all the wonderful colours at once. You can produce many of them from this basic kit and add to your collection when you have more experience.

'Counterenamel', for use on the underside of your work, is a mixture of colours and gives a spotty effect, like the surface of an old gas stove. You do not need to buy it: most people soon acquire a jar of accidentally mixed enamel and use that for counterenamelling. Black or blue enamel looks better if the reverse will show, for instance for a pendant.

Kiln

If you buy a new kiln, choose the largest you can afford. Expensive kilns have temperature controls, but you can work very well with a simple basic model such as the one used in this book. A second-hand one will be cheaper, but do have the wiring checked by a qualified electrician.

If a second hand kiln has enamel spilled inside, heat the kiln, then switch it off, unplug it and scrape gently with an old table knife. Any remaining enamel can be covered with 'batt wash', available from pottery suppliers, or a sheet of ceramic fibre cut to fit the floor of the kiln. It is important to have a clean kiln so that your work does not stick to it.

A kiln, sifters, and firing equipment: protective gloves, safety spectacles, a dust mask, heat-proof surfaces, a firing fork, tongs, a sheet of ceramic fibre, stilts and trivets.

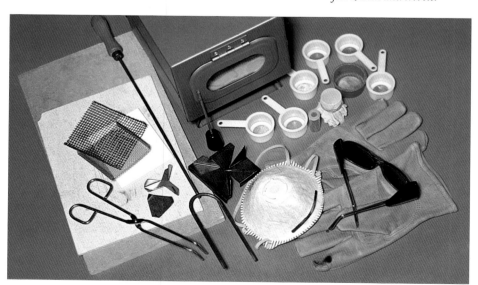

Sifters

Sifters come in different sizes, with different grades of mesh. A good all-purpose sifter is a 5cm (2in) diameter with '80' mesh. A fine mesh plastic tea strainer can be used; coarse mesh allows too much enamel through. A home-made sifter can be made from a film canister, a piece of nylon stocking and a rubber band.

Heat-proof surfaces

You can buy sheets of heat-proof material, but old fire bricks, ceramic tiles or even upturned metal baking trays can be used. The whole area under and around the kiln must be protected so that you can lay hot pieces down beside it.

A firing fork and tongs

To lift things in and out of the kiln. A firing fork is often supplied with the kiln, but you can use an old fish slice, a palette knife or other flat implement with a long handle. Tongs give extra grip when taking things out of the kiln.

A sheet of ceramic fibre

Enamel gets spilt no matter how careful you are, so protect the floor of your kiln with a piece of 5mm (¼in) thick ceramic fibre sheet cut to fit. It is also useful when making tiles or pictures which must be kept flat.

Stilts and trivets

Stilts support work in the kiln. Small ones sit on a trivet; the larger ones can be freestanding. Buy a few of different sizes. They are made from stainless steel or aluminium bronze.

A trivet is a piece of stainless steel wire mesh, turned down on two sides to form legs high enough to slip the firing fork under it. Flat pieces of work can be laid directly on the trivet, provided they do not have enamel on the underside. A piece with enamel on both sides needs a stilt to hold it by the edges and prevent it sticking to the trivet. Trivets can be bought ready made, or you can make them yourself from stainless steel mesh or expanded stainless steel. Do not use ordinary iron mesh or it will soften and break in the kiln.

Safety equipment

Old leather or clean gardening gloves should be worn when using the kiln. Oven gloves are flammable, so they are not suitable. **Latex gloves** should always be worn when using chemicals. They can also prevent greasy finger marks on cleaned copper shapes.

Ordinary spectacles will help to protect your eyes from the infrared heat from the kiln, but, if you are doing a lot of enamelling, it is wise to wear **safety spectacles** sold for welding.

A dust mask should be used to protect yourself from the fine dust left in the air after sifting enamels. It can hang in the air for a surprisingly long time. A mask from a decorating store is better than nothing, but more efficient ones can be bought from pottery suppliers.

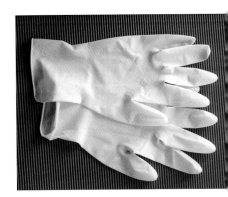

Latex gloves for hand protection when using chemicals and to prevent greasy finger marks on copper.

Other materials

Copper sheet, bowls, blanks and tiles Can all be decorated with enamel.

Clean paper Used when sifting enamels. Pages from glossy magazines or an old telephone directory are ideal.

Scouring powder For cleaning the copper before applying the enamel. An impregnated scouring block sold for removing rust is useful, but not essential. Buy the kind that are solid throughout, those mounted on sponge are too coarse.

Clean jam jars with good lids or film canisters Enamel deteriorates if exposed to damp air, so airtight containers are essential.

Palette knife or old table knife For lifting sifted blanks.

Labels, marker pens and a notebook Keep track of your work, you always think you will remember but it is better to record it and be sure.

Finishing materials Diamond files, carborundum sticks, alundum stone and diamond impregnated material can all be used to smooth the enamel surface and rub out mistakes. One is enough to start with, I suggest the carborundum stick.

Glass brush For cleaning the surface of fired enamel without leaving a residue. It is made of glass fibres in a plastic cover.

Gum or wallpaper paste For holding enamel on curved surfaces. Gum tragacanth solution can be bought, or you can dilute wallpaper paste. The gum can be applied using a plant mister or an old paint brush.

Rubber stamps and an embossing inkpad Quick and easy decorative effects can be obtained with these.

Craft punches and paper embossing tools For cutting out foil shapes and texturing thin copper.

Metal bowl, tin lid, newspaper and dead leaves All used during raku firing.

Swirling tool or wire coat hanger To make a swirling tool from a wire coat hanger, cut off the hook and straighten the rest. File one end of the wire to a point and bend this end over about 2cm (¾in) at right angles. Bend the other end into a handle.

Decorative items Silver or gold foil or leaf, enamel threads, enamel chips and lumps, glass beads and millefiori can be used to decorate enamel. Millefiori should be fired on a sheet of **mica**. Make sure the metal foil and leaf is real silver or gold. Imitation will burn and blacken in the kiln.

*From the left:
A carborundum stick,
diamond impregnated strips
mounted on a wooden ruler
and a scouring block.*

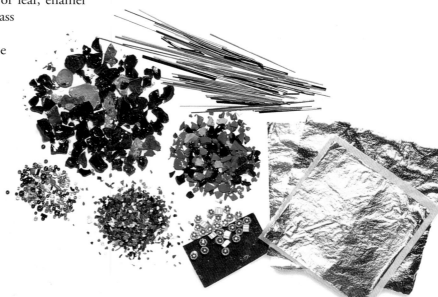

*Gold leaf, gold and silver foils, enamel
threads, beads and millefiori on a sheet of
mica and lumps of enamel, all used to
decorate enamelled pieces.*

A paper crimper can be used to give a wavy effect to wire.

Flat iron For flattening enamelled pieces that have warped.
Tracing paper For transferring designs.
Soapless detergent To clean the metal before enamelling.
Artists' masking film and a **scalpel** For making stencils.
Thin card To make stencils for applying patterns to enamelled surfaces.
Pestle and mortar For grinding transparent enamel to make it more translucent.
Eraser, lino carving tools and **modelling clay** For making 'rubber' stamps.
Pastry brush For applying liquid enamel.
Brass brush To remove copper oxide without damaging the enamel.
Glue syringe To put liquid enamel inside a copper bead.
Rubber-ended pottery tool For drawing bold lines in sifted enamel.
Tweezers To lift small decorative items.
Stripped electrical wire To make decorative lines on enamel.
Aperture cards To frame small enamelled pieces.

A flat iron, dead leaves, metal bowl, tin lid, tracing paper, newspaper, ceramic dish, craft punch, soapless detergent, wire swirling tool, wire coat hanger, artists' masking film, scrap paper, stencils, pestle and mortar, inkpad and rubber stamps, printing block, eraser and modelling clay, pastry brush, brass brush and ceramic fibre sheet, piece of nylon stocking, rubber band and film canister, glue syringe, lino carving tool, marker pen, rubber-ended pottery tool, pencil, glass brush, old paintbrush, tweezers, scalpel, palette knife, scissors, gum tragacanth solution and plant mister, pre-enamelled tile, wire cutters, pliers, stripped electrical wire, copper sheet, bowls, blanks and aperture cards.

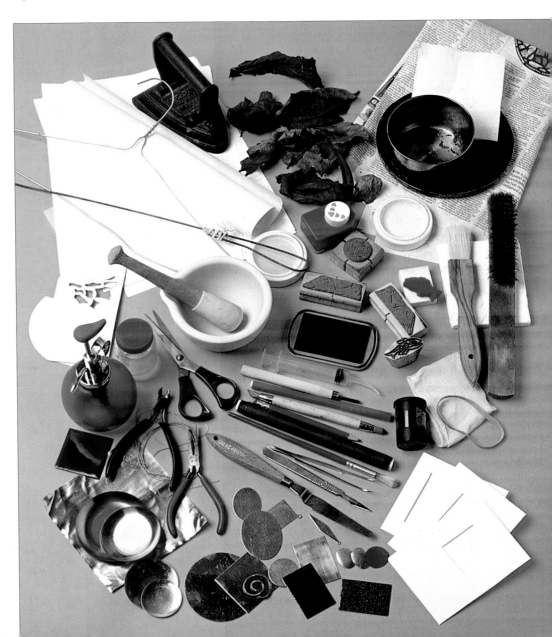

Safety

Enamel is powdered glass so do not eat or inhale it. Kilns are very hot, so everything that has been inside one is also extremely hot. For your own protection, keep these facts in mind all the time and use the safety equipment recommended on page 9.

Never eat, drink, smoke or lick your fingers while working with enamel. If you really have to use your kitchen as a work room, make sure all food and drink is shut away or covered securely before you begin. Store powdered enamel well away from food and make sure the containers are clearly labelled. Once I was given a bag of 'cake colouring' that turned out to be red enamel.

Sifted enamel leaves fine glass dust in the air for at least a couple of hours. Wear a fine dust mask all the time you are working. Fold the papers on which you have been sifting so the dust is trapped inside before disposing of them. Shaking or brushing the paper adds dust to the atmosphere. When you have finished enamelling, wash your hands well and wipe all surfaces with a wet cloth to remove enamel dust safely. Vacuum rather than sweep the floor.

Place your kiln and everything that has been in it on a heat-proof surface; use sturdy implements to put in and remove pieces from the kiln. Long hair should be tied back and woollen clothing is less flammable than cotton or synthetics.

Work in a well ventilated place. This is particularly important if you are working with chemicals such as silver nitrate or acid 'pickle'.

Avoid breathing in any fumes from the kiln. Children are more easily affected than adults, so always use unleaded enamels with them.

If you accidentally drop a piece inside the kiln, switch off and disconnect the kiln before trying to rescue your work. As an added precaution, a fire extinguisher suitable for electrical fires should be kept handy.

Staring into a hot kiln for long periods can damage your eyes over time. Ordinary spectacles provide some protection, and it is safer to look into the kiln from one side of the opening rather than straight in. Safety glasses with tinted lenses can be worn, but sometimes obscure the very details you want to see.

Sifting enamel leaves fine glass dust in the air for hours, so always wear a dust mask when working. The best are available from pottery suppliers.

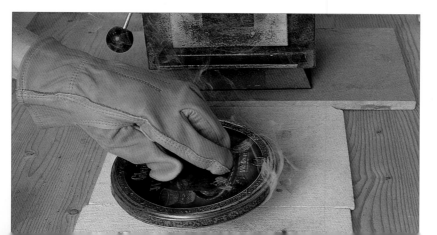

Old leather gloves or clean gardening gloves like those shown here should be worn when using the kiln. Anything that comes out of the kiln will of course be extremely hot.

Colour

We can choose to buy from a huge range of beautiful enamels. Another source of colour is the metal itself. Colour in enamel comes from metal oxides, so even the copper we put them on can, occasionally, contribute its own oxide to thinly applied enamel and add to or alter the appearance of our work.

Opaque enamels cover everything underneath them, while transparent ones let it show. Transparent enamel can be used to alter the colour or shade of opaque enamel. You can get quite a wide range of colours and effects with a small selection of enamels. Here are some possible variations:

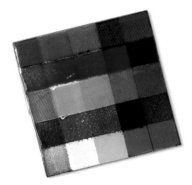

The vertical stripes were applied first, from the left: clear colourless enamel (flux) then opaque white, yellow, red and blue. The horizontal ones from the top are: transparent pale blue, red, yellow and a darker blue. The original colours show at the bottom.

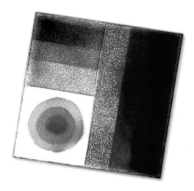

Here you see the effect of applying up to three coats of blue, green and red transparent enamel. The dappled effect is created by a more fluid 'soft' enamel bubbling through a less fluid 'hard' enamel on top during firing.

With transparent enamels the temperature of the kiln can affect the result because the colour of the copper shows through. The copper looks red here because the sample was fired at around 750°C (1382°F).

This sample was fired at a higher temperature so the copper appears golden. For clear transparent colours on pale gold coloured copper, use 850°C (1562°F) or more.

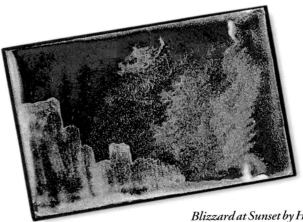

Blizzard at Sunset by Harry Nicholson
15.2 x 10.2cm (6 x 4in)
For this atmospheric panel Harry used two liquid enamels (white and flux). Firing temperatures ranged from 750°C (1382°F) to 780°C (1436°F), resulting in red and magenta shades coming from the copper.

Basic techniques

This is the key to successful enamelling. Once you understand and have worked your way through this basic procedure, all the other techniques in this book are open to you.

You may choose to practise first by making samples of your enamels on small copper blanks before embarking on the full project. In that case follow the instructions until you reach the part dealing with stencilling.

Temperatures in the kiln

Kilns take around 40 minutes to reach enamelling temperatures, so switch on before you begin. If your kiln has a temperature control, set it for 850°C (1562°F). For other types of kiln you can judge the temperature from the colour inside and switch it off and on as required. Keep an eye on a kiln without a temperature control; overheating can damage the elements.

Orangey red = 750°C (1382°F)

Bright red/orange = 850°C (1562°F)

Really hot pale yellow = 900°C (1652°F)

What happens to enamel in the kiln

As enamel fires, certain changes take place. First it will seem to do nothing, then it darkens. Next it begins to melt and looks sugary (sample 1). After that it looks like hot orange peel (sample 2) and eventually becomes smooth and shiny (sample 3).

Sample 1

Sample 2

Sample 3

Pendant project

Enamel likes clean, non-greasy metal and can behave badly if it does not get it. Each time you begin a piece the procedure shown in steps 1–3 below should be carried out. As fingers are naturally oily, hold the blank only by its edges or wear disposable latex gloves.

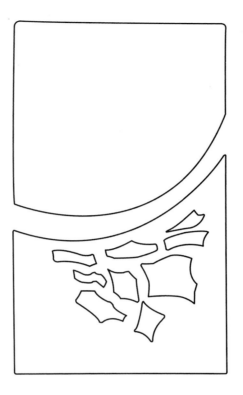

The pattern for the pendant stencils

You will need

Kiln and firing equipment

Oval copper blank, 56 x 37mm (2¼ x 1½in), drilled with a hole

Scouring block or clean cloth and scouring powder

White, blue and red opaque enamels and a sifter

Scrap paper

A few coins or cardboard tube as a prop for the blank

Stilt to support the blank by its edges

Palette knife

Tracing paper and pencil

Card for stencil

Craft knife or scalpel

Old paint brush

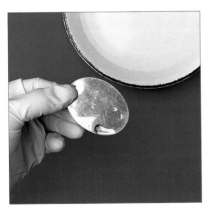

1. Switch on the kiln. Take the copper blank and dip it in water. The water will draw together in beads, showing that the blank is greasy.

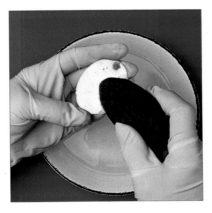

2. Take a scouring block or a clean cloth with scouring powder and scrub the blank thoroughly to remove the grease. You can use a little soapless detergent if necessary. If the copper proves difficult to de-grease, try using saliva.

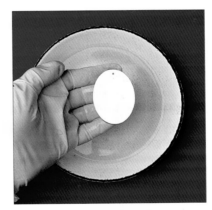

3. The water now covers the copper smoothly without beading, showing that the blank is now quite clean.

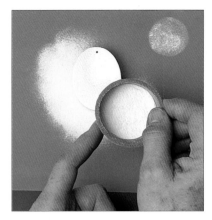

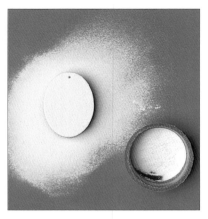

Tips

Do not use your stilts or trivets to support the blank at this stage. They will become covered with a layer of enamel and your work will stick to them.

To get an even coating on the metal, the bottom of the sifter must always be covered with enamel. Put in plenty.

4. Working on a piece of clean scrap paper, place the cleaned blank on a small prop (a section of a cardboard tube or a pile of coins). Half fill a sifter with white enamel. Hold it about 15cm (6in) above the blank and tap the side gently so that the enamel falls in an even layer. Do the edges first, making sure that half the enamel falls on the blank and half on the paper. This is essential for a good edge covering.

5. Stop sifting as soon as you can no longer see the colour of the copper. If the layer is uneven or thicker than the copper, just knock it off on to the paper and try again. Two thin coats, fired separately, are better than one thick one. Use a sharp pencil point or cocktail stick to clear any enamel from the hole. Do this every time you sift on enamel.

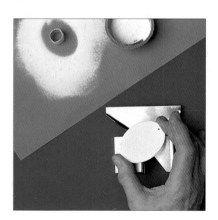

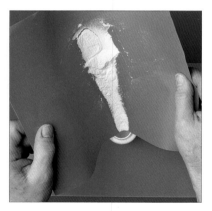

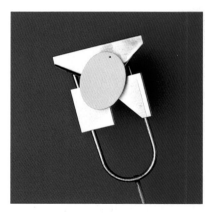

6. Hold the blank by its edges to avoid disturbing the enamel and place it on a stilt. A palette knife can be used to lift it. The stilt should hold the blank by the edges. I used a large stilt that does not need a trivet, but if your stilt is smaller, sit it on a trivet.

7. Before you put the blank in the kiln, pour the spare enamel back into the pot and replace the lid. This prevents it becoming contaminated with dust or black specks from the fired copper. Remember to do this every time.

8. The inside of the kiln should now be a good pale orange colour at 850°C (1562°F). Lift the stilt carefully with the firing fork.

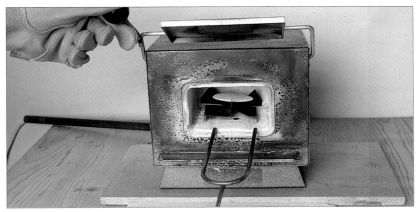

Tips

You can stop at the orange peel stage and make the enamel smooth and shiny only at the last firing. This is a good idea if you are using red or yellow enamels, because they burn easily.

You can open the kiln door as often as you like – it will make the process take longer but will not harm the enamel.

9. Wearing protective gloves, 'fly' the stilt into the kiln and lay it down very gently to avoid shaking off any enamel. The photograph shows an unheated kiln, so that you can see it more clearly. Do not try to shift the stilt once it has landed. How long the enamel will take to fire depends on the size of the blank and the temperature of the kiln. You will soon learn how long your kiln takes. Leave it for one minute and then take a quick look. When the enamel has reached the orange peel or smooth stage, use the firing fork to take it out of the kiln and place it on a heat-proof surface to cool, if possible well away from where you are sifting the enamel. Cooling must take place naturally as any attempt to hurry it will make the enamel pop off.

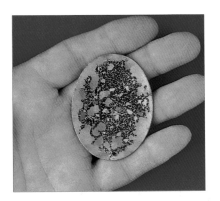

10. Black copper oxide fire scale forms on the back of the piece and, as it cools, may begin to flake off.

11. Keep the fire scale well away from unfired enamel and scrub it off the cooled copper with a scouring block or scouring powder. You do not need to get it all off unless you want to, just the loose particles.

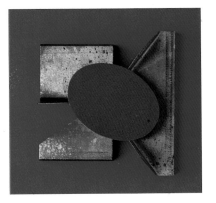

12. Dry the blank, turn it upside down and apply a coat of blue enamel to the back. This is called 'counterenamelling'. It helps to keep the front enamel from popping off the metal. Enamel and metal contract at different rates, so enamelling both sides controls this. Fire and cool the piece as before. After counterenamelling, you still need to clean the edges after each firing.

Tip

When sifting, use a separate piece of scrap paper for each colour to prevent the enamels contaminating each other.

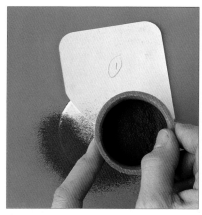

13. Make the stencil by using a pencil and tracing paper to transfer the pattern on page 15 on to card from a cereal box or postcard. Cut it out using a craft knife or scalpel. Lay the blank on scrap paper without a prop. Position the top part of the stencil and sift dark blue enamel over the exposed white area.

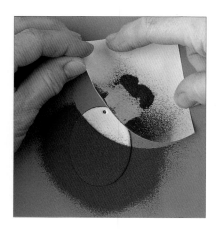

14. Hold the stencil down firmly on the edge furthest from the blank and lift the nearest edge so that the surplus enamel on the stencil falls away from the blank.

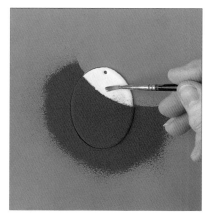

15. The edge can be tidied up with a damp paint brush. Push excess particles of enamel towards the sifted area, do not drag it along the edge or you will dislodge more enamel. Remember, what looks untidy close up becomes perfectly acceptable at a little distance.

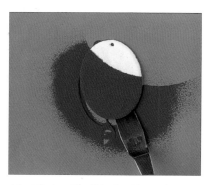

16. Lift the sifted blank with a palette knife, put it on the stilt and fire it again.

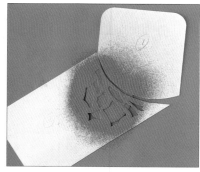

17. Use both parts of the stencil as shown with red enamel to create the final design.

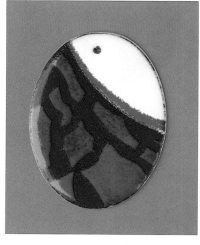

18. Let your kiln cool a little to 750°C (1382°F) before firing, as red enamel prefers a lower temperature. It always looks black when hot but it will stay that way if overheated.

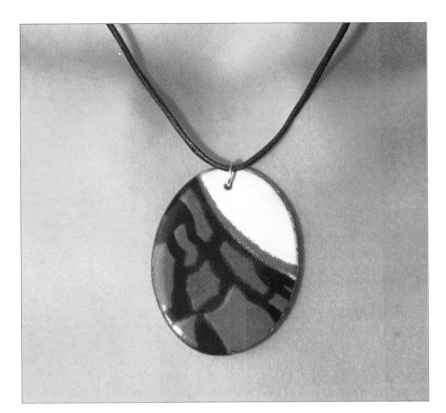

The finished piece mounted as a pendant. For a good finish, clean the edges of the copper so that they shine and paint them with clear nail varnish.

A group of stencilled brooches by May Yarker.

Water Patterns

Clear flux was sifted over a 5cm (2in) copper square and fired in a hot kiln: 900°C (1652°F), to give a golden tone. Then transparent dark brown enamel was stencilled on top. Mounted in an aperture card, the square makes an original greetings card. Epoxy resin is a good adhesive to use when mounting enamels on card.

More advanced stencilling

Card stencils produce shapes with a soft outline. Artists' masking film gives sharper edges and more detailed images. Ordinary sticky back plastic is not suitable as it needs so much effort to remove it that the enamel falls off.

A stencilled pattern can be the finished decoration, or you can add further details in other ways. The background colour looks more interesting if it is not all the same shade. Try two shades of the same colour, two different colours or a combination of opaque and transparent enamels.

Large pictures or wall panels can be built up from separate tiles. Begin by making one or more large stencils and cut them up to fit the individual tiles. Try to design the stencil so that any vertical or horizontal lines come at the edges of the tiles.

To prevent the enamel falling off when the masking film is removed, a dilute solution of gum (or wallpaper paste) is sprayed on before sifting on the enamel. If you use ready-made gum tragacanth, dilute it one part gum to ten parts distilled water. For wallpaper paste, make up a small quantity following the instructions on the packet and dilute it as for gum tragacanth. The exact strength of the solution is not important, but it is better to err on the watery side because too much gum can make enamel cloudy.

The copper tile used for this project was enamelled all over with opaque pale blue with a medium transparent blue on top round the edges.

You will need

Kiln and firing equipment
Artists' masking film and pencil
Scalpel
Pre-enamelled and counterenamelled copper tile blank
Plant mister
Dilute gum solution
Deep blue, black and hard white enamel and red enamel chips and sifter
Scrap paper
Ceramic fibre
Dish of distilled water and old paint brush
Tweezers

The pattern for the vase stencil

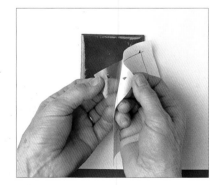

1. Take a piece of artists' masking film a little larger than the pre-enamelled blank. Draw or trace the design on to it. Cut using a scalpel to create a stencil. Peel off the backing and stick the stencil to the blank. For maximum precision, the stencil must be tight to the surface.

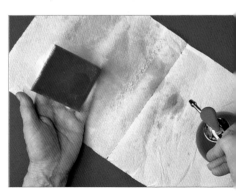

2. Using a plant mister and the dilute gum solution, spray the blank sparingly. A fine mist is what you are aiming for; too wet and the enamel will run. Hold the blank vertically and aim the spray off to one side so that no large drops land on the blank.

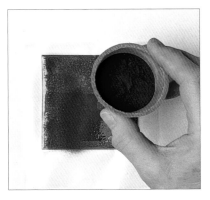

3. Place the blank on scrap paper. Sift deep blue enamel over the damp stencil.

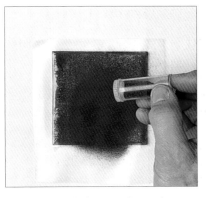

4. Sift a little black enamel over the edges of the stencil to give the vase a shaded, three-dimensional look.

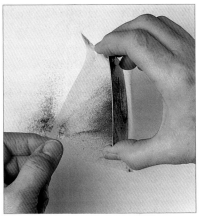

5. Hold the stencilled piece upside down and peel off the masking film. The spare enamel will fall on to the paper. This enamel can be dried and saved for use as counterenamel.

Tip

The ceramic fibre prevents the counterenamel sticking to the trivet and gives a slightly rough surface that is ideal for giving adhesive a good key when mounting the piece. You can use a large stilt instead, but the piece may not remain flat. (If it warps, see Trouble Shooting on page 63.)

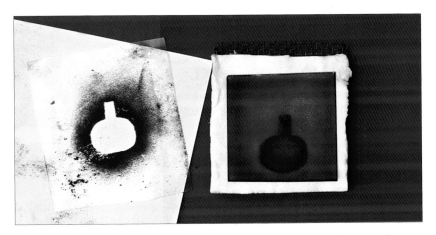

6. With the vase shape now revealed, place the piece on a sheet of ceramic fibre on a trivet. Make sure the enamel is absolutely dry before putting it in the kiln. Any remaining moisture will boil instantly and throw enamel all over your work and the kiln. Fire the piece to the smooth glossy stage.

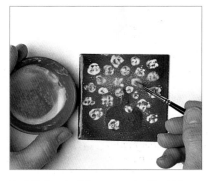

7. Mix hard white enamel with a little distilled water and a few drops of dilute gum solution. Tip the dish so that the water runs down and the enamel becomes like wet sand. Use this and an old paint brush to dab flower heads on your design. Dry the brush and use it to add texture to the flowers.

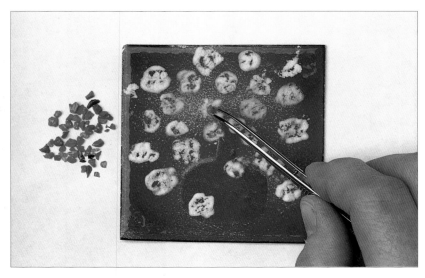

8. Using tweezers, add chips of red enamel to some of the flower centres. Make quite sure all the white enamel is dry before putting it in the kiln. This time, fire it for a shorter time so that the white enamel remains textured and the red chips melt just a little but do not spread. If you take it out too soon, some of the chips may fall off. Just replace them and try again. If it all melts and goes flat, add some more enamel and re-fire.

The finished tile. With its textured surface, it is best mounted and used as a wall decoration, either alone or with others. If it is likely to be placed outside or in a damp place, be sure to protect the edges with a good coat of varnish.

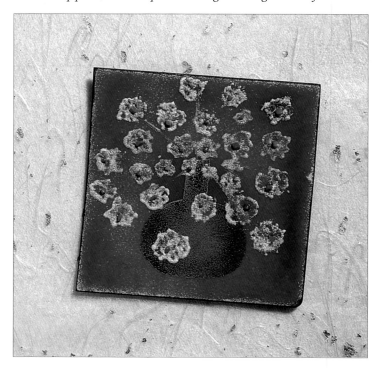

Autumn Leaves

I applied a base coat of clear flux because some transparent enamels react with the copper and turn black. Next came various shades of green and orange transparent enamels. Individual leaf stencils were made with a craft punch and masking film, then transparent black enamel was sifted over. The stencils were removed with tweezers before firing. The piece was mounted on a fabric-covered box using two rows of buttonhole stitch pulled tight.

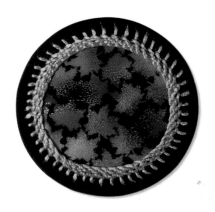

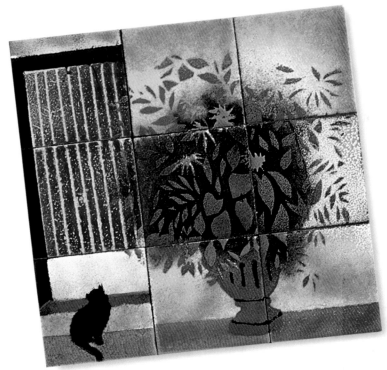

Mediterranean Cat
Nine blanks were laid together and sifted with yellow and cream opaque enamels. They were separated and fired before counterenamelling. The darker stripe was then applied at the bottom. The door and step were done with card stencils and after firing a transparent brown was sifted on to make the shadow of the plant. The leaves, flowers and plant pot were done using masking film stencils. The stencil for the cat was actually a photograph frame. The pieces were then mounted on to a board backing using bathroom sealant, which is excellent for this purpose.

Using household objects as stencils

Look around for things that can be used as stencils. If an object has holes or an interesting edge and will lie flat, you can stencil with it. Kitchen utensils such as potato mashers, leaves, coarse lace, netting from fruit and torn damp newspaper are some ideas. Soft items such as netting will be more obedient if you wet them with gum solution, position and allow them to dry before respraying and applying the enamel.

Sifting red enamel through the lid of a colander, on to a blue enamelled key ring tag.

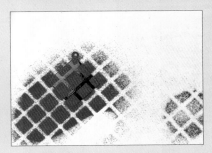

The key ring tag with the colander lid removed.

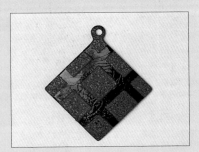

The red enamel has been under-fired to give a textured surface.

Drawing in sifted enamel

A second layer of sifted enamel can be removed in places before firing to show the previously fired underlying colour. It is a more flexible method of decoration than a stencil, as there is no need to consider how the spaces in the stencil join one another; also it allows for last minute alterations.

This project has broad, bold lines drawn freehand in sifted enamel. I used a rubber-ended pottery tool, but you can use any tool you choose.

I chose opaque enamels, but you may decide to make one or both layers of transparent enamel.

You will need:

Kiln and firing equipment
Blue, counterenamelled tile
Plant mister with dilute gum solution (see page 20)
Opaque black enamel and sifter
Scrap paper
Rubber-ended pottery tool

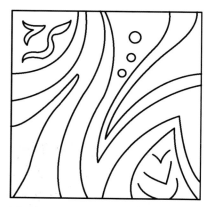

The pattern for the tile drawing

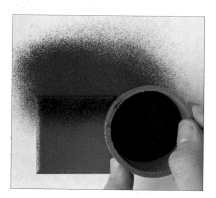

1. Mist the blue tile with gum solution, then sift an even layer of black enamel over the whole tile. Let it dry for a few minutes.

2. Draw the pattern into the enamel with the rubber tool. It has to be done freehand, so have fun making your own version. If you do not like the result, clean it off and try again. Place the tile on a stilt, make sure it is dry and fire until it is smooth and glossy.

Tip
Dry the spare enamel before storing it in a separate container. It is wise to keep enamel with gum in it separate from unused enamel.

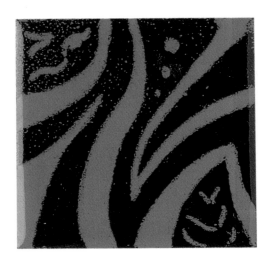

The finished piece. You could vary this idea by having more than one shade or colour underneath, or by firing several complete layers on top of each other and then scrubbing through them using a carborundum stick and water before re-firing to restore the shine.

Portrait of a child by May Yarker

White enamel was sifted over a stencil of the silhouette, with the thickness varying where required. Details were drawn into the enamel before firing and extra white and blue enamels were added later using a small sifter.

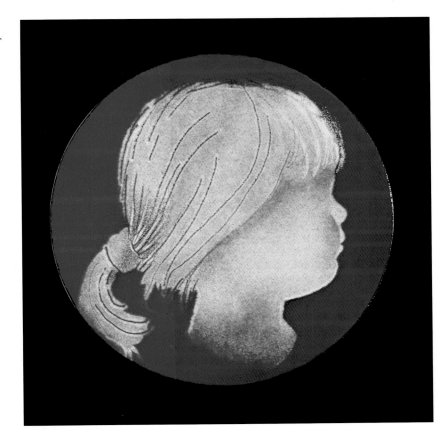

Drawing with a pencil

You can draw and write on enamel using ordinary graphite pencils or crayons. Those sold by pottery suppliers are also suitable. The marks can be rubbed out and redone, but once fired they are permanent. Select the grade of pencil as you would for drawing on paper, I used an HB.

The pattern for the drawing

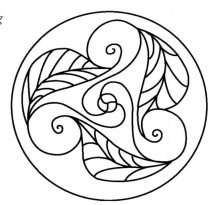

You will need

Kiln and firing equipment
Pre-enamelled and counter-enamelled white circle
Carborundum stick
Dish of water
Glass brush
Tracing paper and pencil

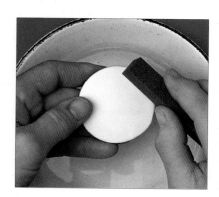

1. Use the carborundum stick and water to file the shine off the pre-enamelled white circle until it is matte. This gives the pencil line a grip. Clean the blank well with a glass brush and water to remove any trace of carborundum.

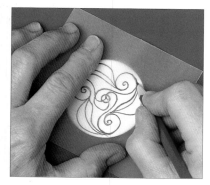

2. Dry the white circle; then use tracing paper to transfer the design on to it.

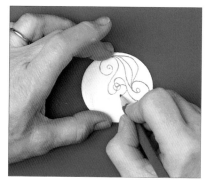

3. Go over the lines of the pattern with pencil to make them clearer. Extra details can be added if you choose. Mistakes can be removed with the carborundum stick and water, but remember this will make the white enamel thinner. Fire the piece until it is shiny again.

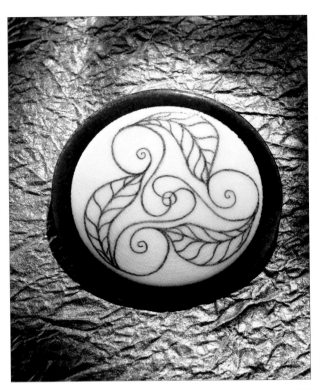

*The finished piece. It can be left like this and the drawing will
be permanent. A thin coat of transparent enamel can be put on
top if you want to add some colour.*

*This method can be used to sign your work, but if you re-fire it
you must cover the pencil marks with clear flux or they will
become fainter each time they go in the kiln.*

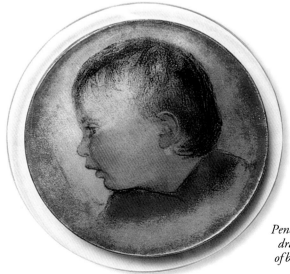

*Pencil drawing in colour by May Yarker,
drawn over clear flux with extra siftings
of both transparent and opaque enamels.*

Drawing with wire

Raised patterns can be made on a pre-enamelled piece, using copper wire from scrap electrical cable. It comes in different grades, so you can vary the thickness of your lines. Use a cable stripper to remove any plastic covering that may be on the wire.

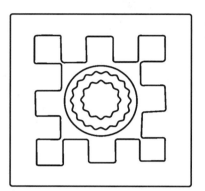

The pattern for the wire shapes

Tip

Full strength gum solution can be either undiluted gum tragacanth or one part of made up wallpaper paste to one part distilled water.

You will need

Kiln and firing equipment
Stripped electrical wire
Wire cutters
Pliers
Paper crimper
Enamelled and counterenamelled blue tile
Tweezers
Old paint brush
Full strength gum solution
Brass brush
Dish of water

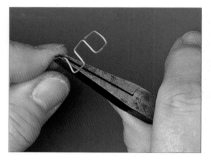

1. Take a piece of wire about 45cm (18in) long and use pliers to bend it into the outer shape shown in the pattern, with the join at the inside angle of one of the corners so it is less visible.

Tip

If the wire is too springy, roll it into a bundle and heat it in the kiln until it is a dull red colour. Drop the hot wire into water to cool it and remove most of the black fire scale, then proceed with step 1.

2. Cut a second length of wire to 10cm (4in) and make a circle to fit inside the first shape. You can do this by wrapping it round some item of a suitable size; I used a piece of 2cm (¾in) dowelling. Cut a third piece of wire to 20cm (8in) and pass it through the crimper to give a regular wavy outline. If you do not have a crimper, use round-nosed pliers. Cut and bend the wire into two smaller circles that fit inside each other.

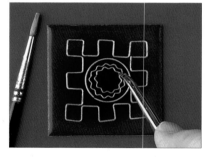

3. Use tweezers to place the wire shapes in position and use the paint brush to feed a little gum under them. Make sure each piece lies flat on the enamel. The gum is necessary to prevent the wire shapes sliding off when the piece is moved to the kiln. Allow the gum to dry completely before firing. Fire the piece until the wire sinks into the surface of the enamel. Allow it to cool naturally.

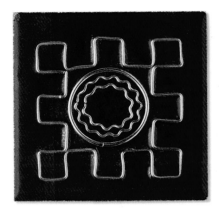

4. Use a brass brush and water to clean off any loose fire scale and brighten the copper wires. To keep the copper wire shining, you can sift and fire clear flux over the whole piece or paint the wires with clear varnish.

Shining wire on strong coloured opaque enamel makes a simple but attractive piece. If you want to add to your design, coloured enamel can be laid in some of the enclosed areas. Use wet enamel powder and a brush as in the More Advanced Stencilling project. Be very careful to remove any stray grains of enamel before firing – they love to climb up the wires when you are not looking!

Tip

Any remaining stubborn scale can be cleaned off with vinegar and salt, scouring powder or the pickle used for cleaning newly soldered metal.

Man in a Window

A layer of flux was fired onto the whole panel; then different thicknesses of copper wire were fired in for the outlines. The panel was built up in layers by sifting shades of both opaque and transparent browns and cream, with touches of green and red. It had at least six siftings and firings before the kiln was turned up to 900°C (1652°F) and the panel fired until it glowed really hot, making the enamel underneath bubble up and vary the tones. The wire was left dark under a fine layer of enamel and fire scale. I cleaned only where the light from the window would fall. To keep larger panels flat, use thicker copper sheet. This panel was made with 1.2mm thick copper.

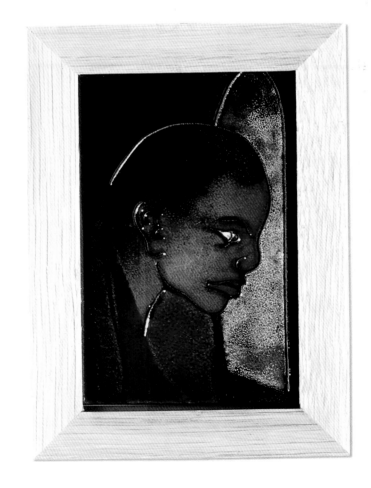

Using rubber stamps

Purchased or home-made rubber stamps make quick, easy and repeatable patterns. Ordinary erasers or modelling clay can be carved with your own original designs using lino cutting tools.

For best results use a fine sifter: '100' mesh or finer. You can make your own sifter: with a rubber band, secure one or two layers of fine nylon stocking over a film canister. Pulling the nylon tight opens the mesh and gives a coarser sifter; leave it slack and only fine particles of enamel will come out. With a little experimentation you will soon find the right tension.

An ordinary ink pad can be used, but it must be quite moist. Those designed for stamping on textiles have thicker ink and stay wet longer, thus giving the enamel a longer time to absorb it and stick.

You will need

Kiln and firing equipment
Rubber stamps and ink pad
Permanent markers
Scrap paper and ruler
White pre-enamelled and counterenamelled tile
Black opaque enamel
Fine or home-made sifter

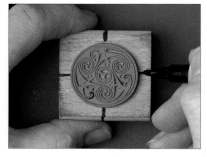

1. Mark the centres of the sides of the block on which the rubber stamp is mounted and continue the lines round to the other side. Do not depend on the picture on top being central.

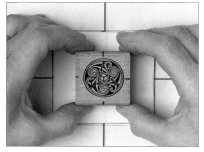

2. On scrap paper draw two lines at right angles to each other. Lay your tile on top, making sure the lines match the centre of each side of the tile. Have the enamel ready in the sifter; then press the stamp on the ink pad. Line up the marks on the stamp with those on the paper and press it firmly on to the tile.

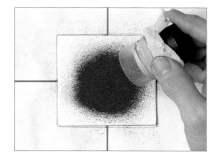

3. Quickly sift the enamel over the stamped image and give it a few minutes to dry.

4. Lift the tile and tap it gently to remove excess enamel. Resist the temptation to use a brush to clean the tile. It will leave a 'tidemark'. If you are not satisfied with the image, wipe it off and try again. Make sure the ink is dry and then fire it.

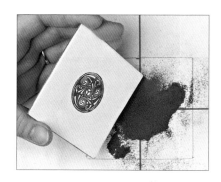

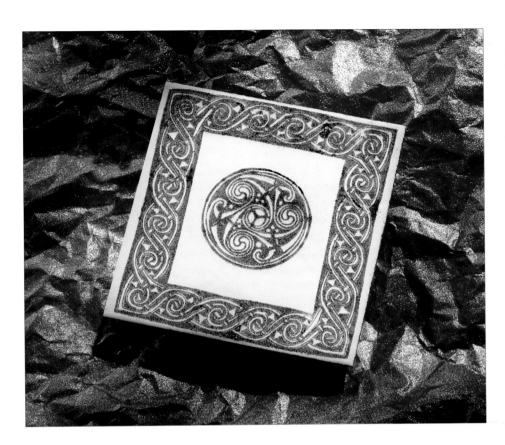

The finished tile. After step 4, I stamped the tile with a second stamp to make a Celtic border, sifted enamel over it as before and fired it again.

If you want to add colour to a background, it is best done before the rubber stamps are used, as in this Celtic style pendant. The enamel on a stamped design is very thin, so may sink into the background if it is fired too often.

A jewellery box by Janet Notman. Stamps for the birds, leaves and the ochre flower were made from erasers, while the centre of the flower was stamped with a small piece of plastic sponge.

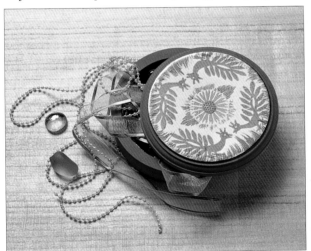

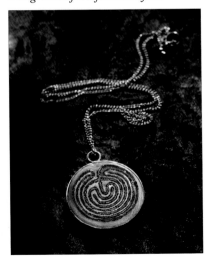

Sgraffito and liquid enamel

Liquid enamel contains much finer particles than powder enamel, thus making it possible to draw very detailed patterns into it. It is made in white and a range of basic opaque colours, plus clear flux. It contains some fine clay, which gives it a rather matte surface. Powder enamels can be applied over it to give a more shiny finish.

Liquid enamel forms a very thin layer on the copper, so it is not always necessary to counterenamel, especially if the metal is quite thick.

Liquid enamel is usually unleaded and if it is applied on top of leaded powder enamel, it will 'craze' – an effect which can look quite interesting in small areas.

All the enamel and clay particles sink to the bottom of liquid enamel, so it is essential to mix it well before use.

The inspiration for this project was a holiday photograph of a Nile village near the Valley of the Kings, Egypt.

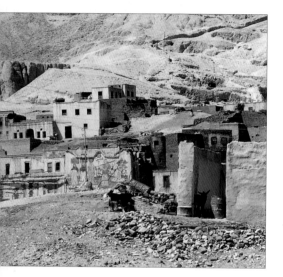

You will need

Kiln and firing equipment
White liquid enamel
Old table knife and teaspoon
Dish and distilled water
Lint-free rag
Pastry brush
Rectangular copper blank, Pencil
Glass brush
Clear flux and sifter

Tip

Distilled water is necessary if you live in a hard water area. Calcium in tap water can make enamel cloudy.

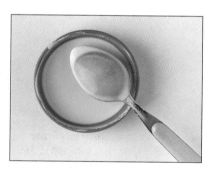

1. Liquid enamel is sold in 250ml (8½fl oz) bottles. Use an old table knife to stir the whole quantity until it is quite smooth. Put a couple of tablespoons of well stirred liquid enamel into a small dish and dilute it with distilled water. The mixture should have the consistency of full cream milk.

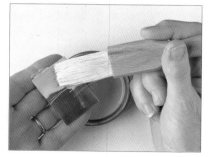

2. Use a little liquid enamel on a lint-free rag to clean and de-grease the copper. Brush or pour the mixture on to your clean and de-greased copper blank. Cover the whole surface and then tip off the excess, tapping the blank lightly to even the layer. The copper shows pink under the wet enamel, which will become opaque white as it dries. Leave the enamel to dry thoroughly.

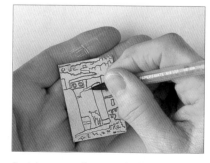

3. Use a pencil, empty ballpoint pen or other pointed tool to draw the lines through the enamel, revealing the bare copper. If the enamel drags into little lumps, it is not quite dry. If it chips badly, it is too dry and can be rehydrated by placing it on a damp sponge in a plastic container for about an hour. To help prevent chips in the enamel as you draw, you can do each line first with a fine sewing needle.

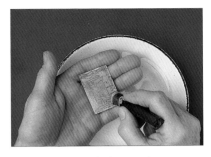

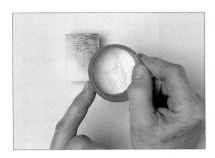

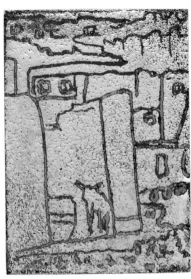

4. Fire the piece in the usual way, remembering that it will be a little less shiny than usual; then let it cool. Use a glass brush and water to remove any bits of loose fire scale. If you like the result at this stage, it can be regarded as finished.

5. For a smooth, shining finish, sift clear flux over the whole piece and fire it again. The lines of the drawing will turn red or gold, depending on the heat of the kiln and how much fire scale is left.

The finished piece. I diluted the enamel so that some colour from the copper would show through the plain areas. For a more opaque white you can use liquid enamel just as it comes out of the bottle, but it can be more difficult to draw into without chipping.

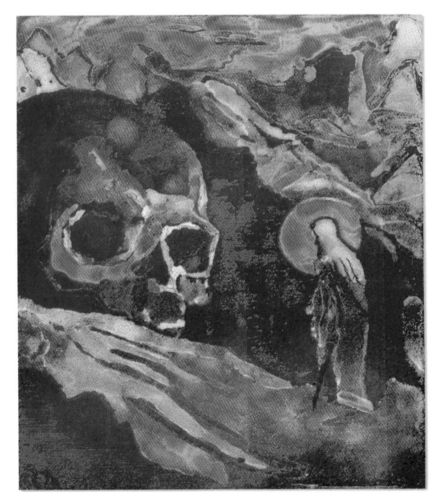

The Skull of the Giant by Harry Nicholson, inspired by a painting by Nicholas Roerich

Harry drew the outline of his picture on to base copper using wax pencil. He then painted areas where he wanted gold and white with a mixture of liquid flux and liquid white enamel, before firing it at 800°C (1427°F). After rubbing off loose fire scale, he painted over the remaining scale and bare metal with liquid flux and fired again. Rich reds appeared from the fire scale. The piece was counterenamelled and finished with sifted coats of soft finishing flux, with the temperature never being allowed to rise above 825°C (1517°F).

Swirling

Beautiful abstract swirls of colour can be produced on jewellery and other enamelled items by this simple technique.

Chips and lumps of enamel make the boldest patterns, but you can use little piles of powdered enamel. For the most interesting effects, use a mixture of opaque and transparent lumps.

Your kiln must be really hot for this: 900°C (1652°F), and it is wise to wear safety spectacles because you have to look into the hot kiln for longer than usual. Step 2 was photographed in a cold kiln in order to show clearly what you need to do. In reality the kiln would be a glowing pale yellow colour.

You will need

Kiln and firing equipment

Enamelled and counterenamelled blank

Enamel chips or lumps in various sizes and colours

Tweezers

Full strength gum solution (see page 28) and paper tissue

Swirling tool (see page 10)

1. Using tweezers, dip each chip or lump in gum solution before placing it on the enamelled blank. Keep them away from the edges in case they fall off in the kiln. Remove excess gum with a paper tissue. Place the blank very securely on a stilt. Make sure all the gum solution is quite dry before firing.

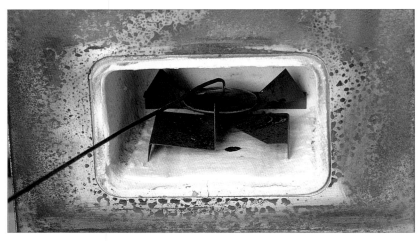

2. Fire the piece until it is really glowing hot, then open the kiln door and heat the end of the swirling tool for a moment. When the enamel is runny, dip the heated tip of the swirling tool into it and draw it through the enamel chips towards you in an 'S' shape. Try not to go right through to the copper; keep the swirling tool in the enamel only. Do not push the tool; if you want to scroll in the opposite direction, turn the piece and reheat it. Take the tool out of the kiln and close the door to allow the disturbed enamel to settle flat again.

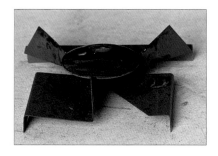

3. When the surface of the enamel is flat, take it out and leave it to cool.

Tip

The enamel must be fairly liquid for swirling. If it resists your efforts to stir it, close the kiln and heat it some more.

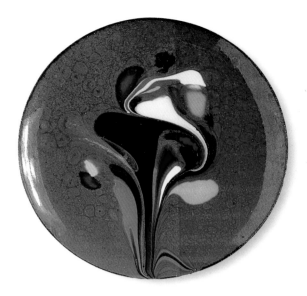

Large and small areas of colour were achieved by drawing the swirling tool through the enamel only once. The more you swirl, the fussier the result becomes. Keep the whole thing simple by using only a few chips and by swirling only once or twice through the hot enamel.

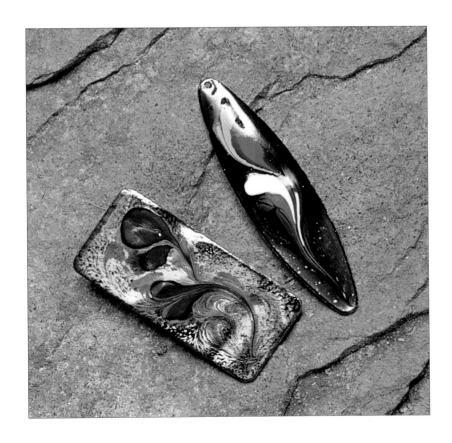

Left: a rectangular swirled brooch by Kathleen Kay. Right: a swirled pendant made from opaque enamel lumps over a transparent dark green base, by Dorothy Cockrell.

Crazy paving

This is great fun: no artistic ability or steady hand is required and every piece is different. Originality is guaranteed. This project also uses swirling, but in a much less controlled manner than in the previous one. As well as chips and lumps of enamel, you can add piles of powder enamel and enamel threads.

You can use crazy paving on jewellery, box lids, tiles, the bottom of a bowl, or anywhere you like.

1. Take a piece of thin copper sheet the size of your largest trivet. Do not de-grease or counterenamel it, as you want the enamel to come off easily. Place the sheet on the trivet and then put a good collection of enamel chips in the centre. The enamel should be thicker than usual after it is fired. Fire and swirl it as in the previous project. Let it cool.

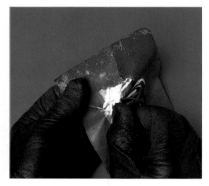

2. Wearing old leather gloves, peel the blackened copper away from the enamel. Do not worry if the enamel breaks into pieces, this is what you want. The piece of copper sheet can be hammered flat and reused.

3. Arrange the broken pieces of enamel on the pre-enamelled black square. With a brush, feed in a little gum solution to help keep them in place. Alternatively, you can use a thin sifting of enamel underneath to stop them sliding around. Make sure the gum is dry and then fire until the enamel pieces sink into the black base coat. They will remain slightly higher than the black enamel, with rounded edges.

The finished piece. To give your piece a title, turn it to the view that most pleases you and use your imagination.

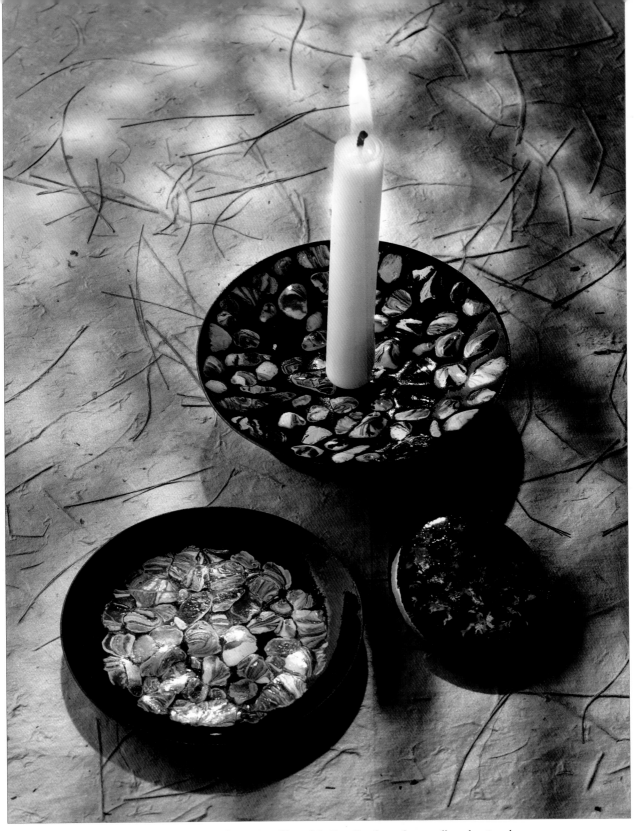

This candlestick, small saucer and brooch by Jum Duckworth were all made using the crazy paving technique. He varied the effects by spacing the pieces of enamel differently.

Insets

Other types of glass and metal can be used to decorate your enamels. Copper, silver and gold are suitable. Aluminium foil will melt and you cannot put enamel on top of it, but it can look effective. Brass and steel will not adhere to the enamel.

Millefiori are pretty and can be used in a group or with other decorative items. They are very effective when massed together. They do not melt as much as enamel does; long firing will flatten and spread them, but they always sit up on the surface of the enamel. Examine the millefiori carefully before using them. Lopsided or broken ones should be discarded, although you can use a diamond file to level the ends and make them sit straight.

Results can be unpredictable when using millefiori, so it is a good idea to fire them first on a piece of mica. Then you can choose the best one for your design. If you want a particular arrangement, fire it first on mica and then it will stay in shape when fired into the enamel. Always file off any traces of mica that have stuck to the millefiori.

Massed tiny millefiori make a pretty earring, but supporting such a small item in the kiln can be a problem especially if it is for pierced ears. Stick the post into a piece of ceramic fibre to hold it securely. There is no need to counterenamel a small domed shape like this. If you are constructing the earring yourself, always use hard or enamelling grade silver solder and apply more than you would normally. Keep counterenamel away from solder, as enamel can act as a flux and loosen it.

Tip
9 carat gold wire (yellow or white gold) makes good earring posts that do not bend in use.

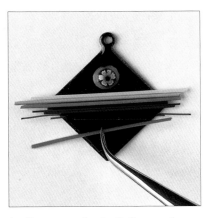

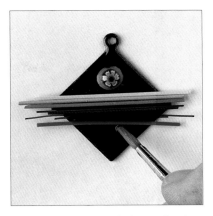

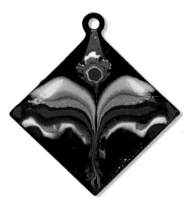

1. Place a pre-fired millefiore on the pendant blank and use tweezers to arrange enamel threads beside it. They should stick out a bit at the sides because they will shrink in the kiln, giving the effect of leaves when the swirling tool is pulled through them.

2. Feed a little gum solution under the threads and the millefiore. Place the piece on a stilt so that it is held securely and the threads do not touch the stilt. Make sure it is quite dry before firing it.

3. Fire the piece at a higher temperature and for longer than usual. When it is really hot and the threads have melted into the enamel, place the heated tip of your swirling tool just in front of the millefiore and draw it through the threads down to the edge of the pendant. If the enamel resists, heat it for longer and try again. Note that millefiori themselves are too stiff to swirl. Remove the swirling tool and fire the piece for a moment longer to allow the enamel to settle.

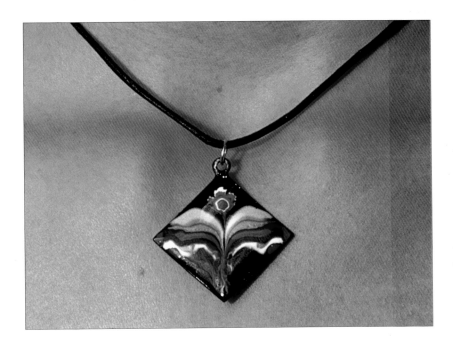

The finished piece worn as a pendant. A plain, dark background is a good foil for the opaque colours of the millefiore and enamel threads. If your chosen millefiore is transparent, see how it looks over your test pieces to find the best background colour.

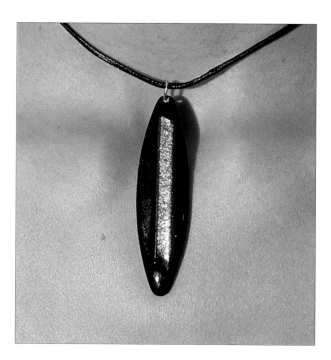

Dichroic glass on dark enamel can make an eye-catching piece of jewellery. First, fire two or three layers of soft enamel (see page 50) on to the blank. Buy the thin type of dichroic glass: 2.5mm (0.1in) or less. If it is too thick, it will pull free from the enamel as it cools. Place it on the enamelled blank for firing with the dichroic coating underneath – look at the glass sideways to see where it is.

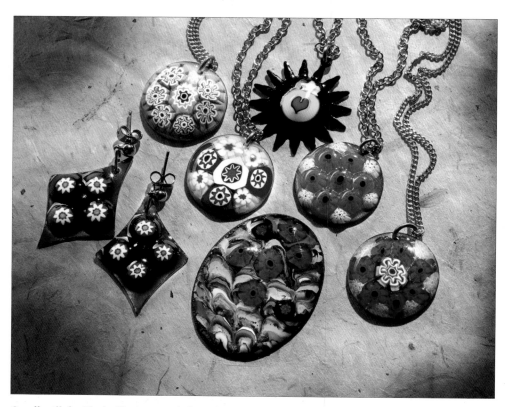

Small millefiori look effective crowded together to cover the copper blank, or they can be arranged to emphasise the shape of the piece. A larger one on its own makes a more striking statement.

An enamelled house number. For really clean, crisp edges, make the number and enamel it separately first. I used 0.5mm (0.023in) thick copper, cut out the number with a jeweller's saw and enamelled the front only, before firing it onto the thicker, pre-enamelled back plate. If you use thinner copper sheet, you can cut it with old scissors or snips and hammer it flat before enamelling.

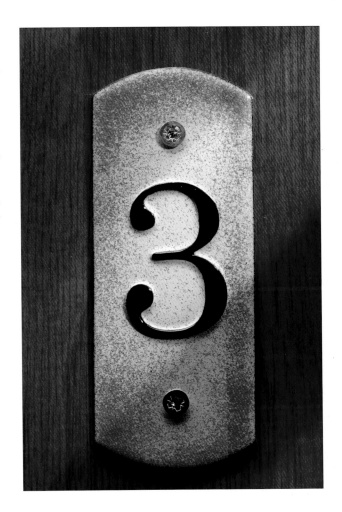

By now you will be familiar with the black scale that forms in the kiln and falls off the back of your copper blanks. Occasionally it comes away in large, fragile pieces. Preserve these carefully; they can be used as decoration and inspiration for a design. Use tweezers to arrange them delicately on a pre-enamelled blank. If necessary feed a little gum solution under them, then dry and fire as usual.

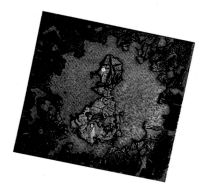

The finished fire scale piece. Further layers of transparent enamel can be applied. Here, 'Scrooge' was given a thin layer of clear flux and a white glass bead for an eye.

Using gold and silver foil

A little gold or silver foil gives your work a touch of luxury and lifts a merely pleasant colour scheme by highlighting certain parts of it. You must use pure gold or pure silver foil; imitations burn black in the kiln.

One sheet of foil can last a long time, because even a tiny piece has an effect much greater than its actual size, so every scrap is useful. Handle it inside tracing or tissue paper and store it carefully between pieces of cardboard, as wrinkles are very hard to remove.

For this project I used a circular blank that had been pre-enamelled in shades of transparent brown over a layer of flux, and counterenamelled.

You will need

Kiln and firing equipment

Sheet of pure gold foil

Sheet of pure silver foil

Tracing paper

Pre-enamelled and counterenamelled brown circle, diameter 7.5cm (3in)

Dilute gum solution (see page 20) and paint brush

Clear flux and sifter

1. Sandwich a sheet of gold foil inside a folded sheet of tracing paper, tear off a few strips and tear them into rough squares of varying sizes. Tearing up pure gold feels really wicked and extravagant. Enjoy it!

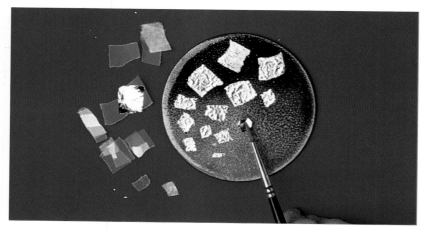

2. Use a damp brush to lift and place the gold squares on to your pre-enamelled blank. Then use the brush to feed a drop of gum solution under them; this allows you to move the foil squares around easily. Repeat steps 1 and 2 using silver foil. Squeeze the brush dry and use it to mop up any excess gum solution. Leave the whole piece to dry thoroughly before firing; you do not want steam in the kiln to rearrange your carefully placed pieces of foil. Fire until the foil has settled into the surface of the enamel. When the piece has cooled, sift on a thin layer of clear flux and fire it again.

Tip

If you cannot see when the foil has settled, look at the colour of the stilt. If it is glowing red, the piece should be ready to take out of the kiln.

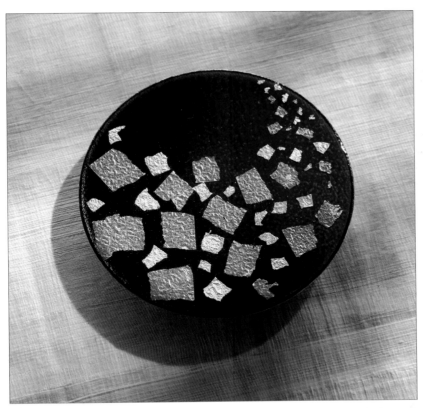

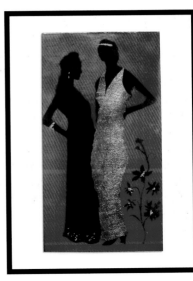

The finished piece. The circle can be backed with felt to use as a coaster and the layer of clear flux fired on top protects the foil. Gold foil sometimes looks dull when it has been fired and a thin layer of transparent enamel on top will restore its full colour. Yellow or red transparent enamels look good on gold, but will produce a rather nasty yellow colour on silver. I used clear flux because of the silver foil.

Model Girls

The figures and flowers were stencilled in transparent black enamel over a fired layer of flux. After the black enamel was fired, the dresses were cut from gold foil, laid in place and gum solution fed in at one end. It spread under the foil, making it lie flat. The piece was left overnight to dry before firing. Foil does not expand and contract in the kiln in quite the same way as the enamel; this gives a textured surface that reflects light well and is most noticeable with larger pieces of foil.

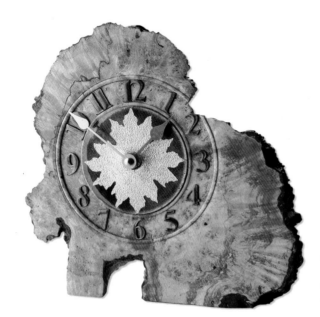

A clock carved and made by Robert Eves, with an enamelled face by Dorothy Cockrell. Collaboration with another craftsman gives an extra dimension to the work of both. Craft fairs are good places to find handmade items to inspire ideas for enamelling.

Wet laying enamel

A layer of silver or gold foil reflects light through transparent enamel. Used on top of copper, foil gives the appearance of solid silver or gold metal at a fraction of the cost.

The clearer the enamel is, the greater the beauty of the finished piece; so in this project the enamel is re-ground and washed to remove any trace of cloudiness. Distilled water must be used, as hard tap water will make transparent enamel cloudy. The enamel is then 'wet laid' with a brush. A dental spatula or a quill can also be used.

If you prefer to sift the enamel on, grind and wash it then dry it on top of the kiln. In that case you need to prepare a larger quantity of enamel.

Tip

To help moisture to escape from under the foil when it is drying, you can pierce it all over, while it is still sandwiched inside the tracing paper, with a very fine sewing needle.

1. Fold the tracing paper in half and draw the outline of the pendant on it. Sandwich the silver foil between the layers of paper and cut through all three layers a little outside the pencil line, leaving a margin all the way round.

2. Remove the top layer of paper and place the pendant face down on the foil. Use a brush to feed a drop of gum solution in at one end of the pendant. Turn it over, remove the remaining paper and very gently smooth the foil over the pendant with the brush.

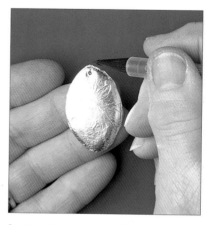

3. Tuck the margin under the edges of the pendant. Use a sharp pencil to make a hole over that of the pendant. Place the pendant on the firing stilt and leave it to dry in a warm place. Fire it when you are quite sure it is dry.

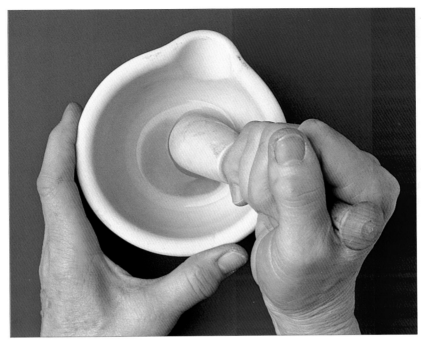

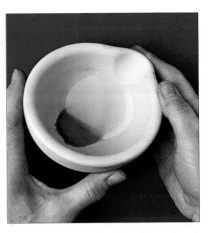

4. Put about 1 teaspoonful of transparent blue enamel powder into a mortar and cover it with distilled water. Lean on the pestle and rock it to and fro, crushing the enamel into a finer powder. The water will become cloudy.

5. When you can feel that the grains of enamel have become finer, let it settle and then pour off the cloudy water, leaving the enamel at the bottom of the mortar. Pour in some more distilled water, swill it through the enamel and let it settle again before pouring it off as before. Repeat this until the water runs clear.

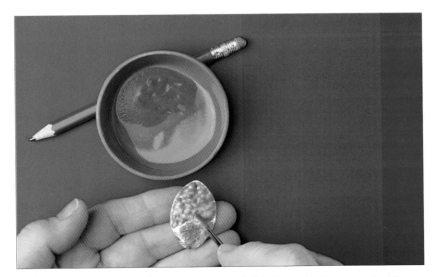

Tip

Lots of small dabs of wet enamel spread more evenly than one big one. If the enamel will not spread, pick up a touch more water. Draw off the excess with paper tissue.

6. Tip the enamel and a little water into a small dish. Prop the dish up so that the enamel is mostly above the water. Use the paint brush to collect small amounts of enamel from just above the water and lay them on the foil. Begin at one end and apply a thin layer all over, making it as even as you can.

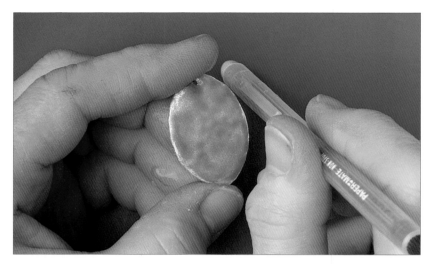

7. Hold the pendant by its edges and give it a couple of sharp taps with the pencil. This should level the enamel and knock out any air bubbles.

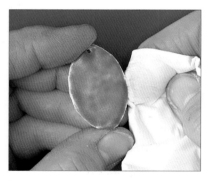

8. Use a paper tissue wrapped around your finger to draw the water from the edge of the pendant. Hold the tissue against the edge and watch as the water moves towards it from all parts of the pendant. When all the surplus water has gone, check that the hole is clear of enamel, then dry the piece well before firing.

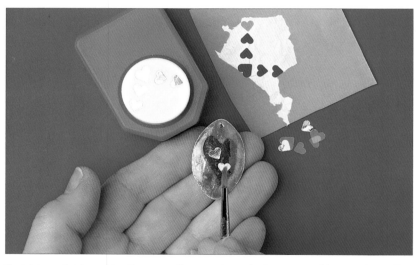

9. Using artists' masking film, stencil a green heart in the centre of the pendant, sift on dry enamel and fire again. Sandwich the gold foil between pieces of tracing paper and use a craft punch to punch out heart shapes. Use a damp brush to place these on the green heart; a little gum solution allows you to move them into position. Dry the pendant well and then fire again.

Tip

To test for dryness before firing, hold the piece in the klin on its kiln support with the firing fork for a few seconds, then take it out and look at it against the light to check for steam.

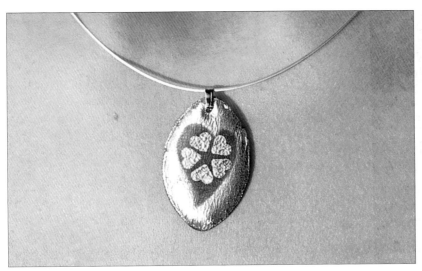

The finished hearts pendant. If the gold foil has darkened, it can be given a top coat of clear flux, but a pendant does not need protection in the same way that a coaster does. You can see how grinding and washing the blue enamel has made it much clearer and brighter than the green, which was sifted on in the normal way.

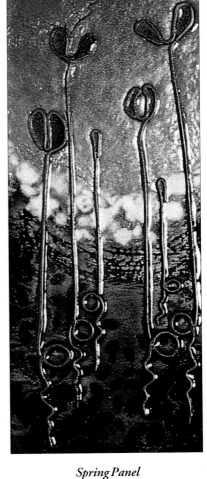

Spring Panel

The lower part of this panel was punched and textured before enamelling. These marks appear darker under transparent brown enamels. Silver foil was used under shades of transparent blue for the sky. The snow and the green tips of the growing shoots (made of copper wire) were wet laid.

Foiled Fish

Foil can be textured before being applied to the enamelled blank. Here the foil was sandwiched between two sheets of tissue paper, then pressed hard onto a piece of plastic netting from a bag of fruit. Many things around the house or garden will produce an interesting texture. Experiment with kitchen foil before using the silver or gold.

Using gold and silver leaf

Leaf is much thinner and less expensive than foil. When fired over enamel, it tears, giving an attractive 'cracked earth' effect. Red gold, yellow gold or silver leaf give the best effects, green gold does not tear so well. Like the foil, it must be real gold and not imitation. Leaf is sold in little books, sandwiched between sheets of tissue paper. Sometimes it is attached to the tissue paper, which makes it easier to handle, but you then have the problem of removing the paper. I prefer the loose sheets.

You will need

Kiln and firing equipment
Book of gold leaf
Tracing paper and pencil
Scissors
Pre-enamelled and counterenamelled circle blank

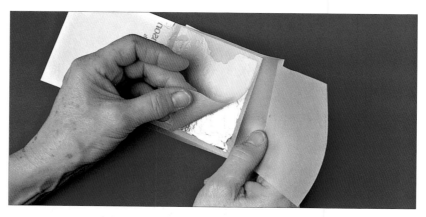

1. Fold a small sheet of tracing paper in half. Open the book of gold leaf so that the first sheet is still covered with tissue paper. Slide half the tracing paper under the second page of tissue paper, taking care not to damage the second sheet of gold leaf. Close the folded tracing paper to make a layered sandwich of tracing paper, tissue paper, gold leaf, tissue paper and tracing paper. Very carefully tear this sandwich out of the book.

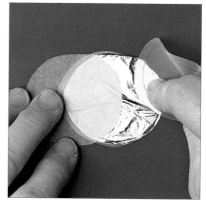

2. Draw and cut round the shape of the pre-enamelled blank, leaving a margin as you would with foil. Remove the top layers of tracing and tissue paper. If the gold leaf tries to escape, hold it down with the paper. Never touch it with your fingers.

3. Lick your finger and run it over the front of the enamelled blank. Drop the blank face down on to the gold foil. Turn the whole thing over with the two remaining layers of paper still in place and put it on a stilt. Remove the paper. Do not worry if the gold leaf is untidy, all will come right in the kiln. There is no need to leave it to dry. As it fires the gold leaf will settle into the enamel. Once this happens, continue to fire it until you see the leaf begin to tear. Remove it from the kiln as soon as you have an effect that you like. The longer it is fired, the bigger the spaces will be.

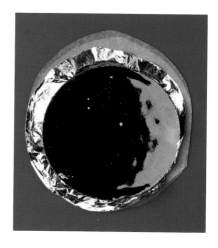

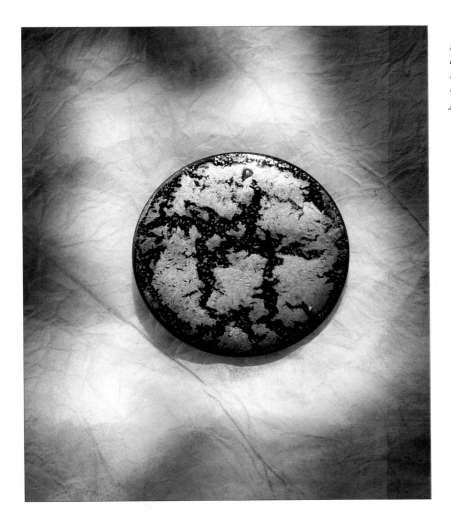

The finished piece. Gold leaf is so thin that the underlying enamel protects it and there is no need to add flux. A thin layer of transparent enamel can be fired over it if you wish, but the more it is fired the fainter the gold becomes.

Brooches

The red brooch was done over transparent red enamel. After an all-over layer of gold leaf was fired in, two scraps of red gold leaf were laid on top at each side. They were fired for a shorter time so that they did not tear and developed an iridescent effect. For the blue/black brooch, silver leaf was used over the whole piece; then transparent purple and blue enamels were applied with a stencil. Two pieces of fine silver cloisonné wire were passed through a paper crimper and fired in. The silver leaf has sunk a little under the top layers of enamel to give a subtle effect. The finished piece was glued onto a sterling silver circle with a pin on the back.

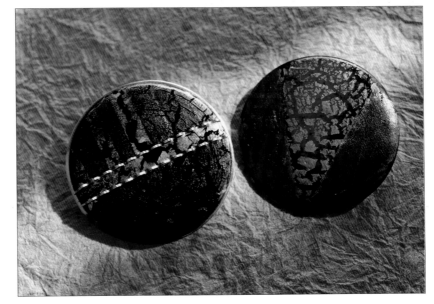

Hard and soft enamels

Exciting and unusual effects can be produced by putting hard enamels on top of soft ones. Soft enamels are more fluid and will bubble up through the less fluid hard enamel in the kiln. A combination of two opaque enamels (one harder than the other), or a transparent and an opaque, can produce interesting results. Try several layers of different enamels over a soft white or soft flux, then fire the piece at 900°C (1652°F) until it is really hot.

White enamels and fluxes are made in varying degrees of hardness. They may be labelled as 'hard white' or 'soft flux', or you can ask the supplier. The softest normal flux is 'finishing flux' and the hardest is 'diamond flux' (T700), with many others in between. Colours are not labelled in this way.

For this project, you need to find a white enamel that will break up over flux. Test your flux and white enamels before beginning. For example, try a layer of white over your flux; then reverse them. You should find some of your enamels fall through others and break up. For this project I have used 'normal' flux and hard white.

Test pieces of different white enamels over and under various fluxes. The top one shows diamond flux (T700) over a soft white, while the others illustrate that different combinations produce varied effects. The base coat of the blue/green sample was a medium white; the green was harder and fell through, while the blue did not. Do test your flux and white enamels before embarking on this project. You need to find a white enamel that will break up over flux.

1. Apply and fire a coat of flux, then counterenamel the circle. Make a stencil from the masking film and apply the outer part to the blank so that the point of the tree is in line with the hole. Mist with gum solution and sift on the paler of your two green enamels. Remove the stencil, dry and fire the piece. Make another stencil with a slightly narrower tree. Use the outer part of this stencil with your darker green enamel to make a two-toned tree. Dry and fire as before.

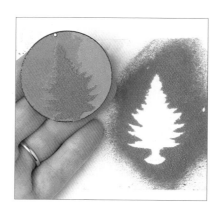

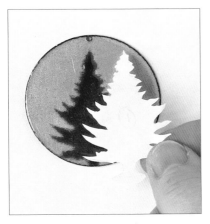

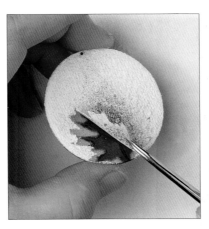

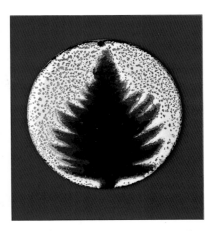

2. Use the inner part of the larger stencil to cover the tree, leaving a tiny bit hanging over the edge to aid removal later. At this stage, turn your kiln up to 900°C (1652°F).

3. Mist with gum solution and sift on hard white enamel. Peel off the stencil using tweezers. Dry and fire until the white enamel breaks up over the flux.

4. After firing, the hard white enamel has broken up, leaving clear spots to look like snow. Using two shades of green, rather than one, adds interest to the tree.

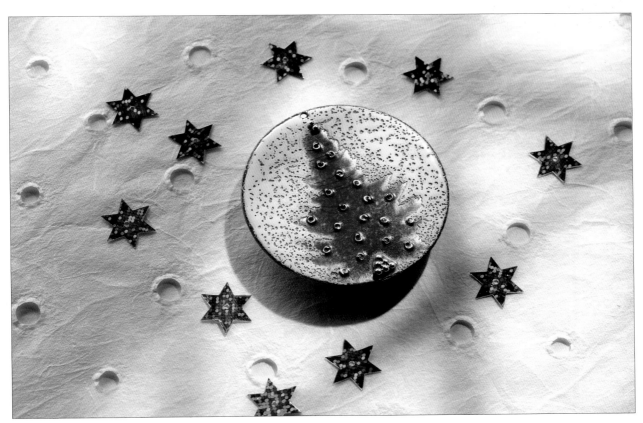

This Christmas tree has been decorated with silver jump rings and tiny silver balls (grains), which were fixed with full strength gum solution and then fired in. Coloured glass beads, enamel chips or pieces of gold and silver foil could be used too.

Meconopsis Coaster

This was planned to be a pink and blue flower with white on a black background. The result was boring so I turned my kiln up really high, sifted hard (diamond) flux over the whole piece and fired it until it was almost incandescent. The hard flux fell all the way down to the copper and the other enamels bubbled through, making it much more exciting. Try this if you really despair of a piece.

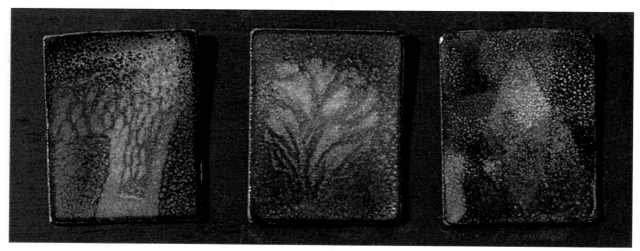

Panels by Veronica Matthew

These were done with layers of hard and soft enamel. Soft white enamel was applied over a base coat of various opaque and transparent enamels and then other colours sifted on top. When fired, the 'sandwiches' of colour bubbled through each other.

Left to right: Spring Tree: opaque and transparent yellow on the base, then soft white under various transparent enamels. For the tree, transparent green was sifted on over a stencil and pushed around with an orange stick.

Little Flower: clear flux, amber and pink transparent enamels on the base, then soft white under various opaque and transparent colours. To make the flower, some enamel was rubbed away to expose the white and this was covered by pink and turquoise transparents.

Magic Mountain: clear flux and opaque turquoise on the base, then soft white. Yellow, lavender, blue, orange and red opaque enamels were applied with stencils to make the shapes. The last layer was pink and black transparents to enrich the colours, soften the shapes and add texture.

Winter Tree, Window and Blue Wood by Veronica Matthew

Three more variations using 'sandwiches' of enamel fired until beautiful and interesting effects were achieved. Stencils and drawing into the dry enamel gave more control and extra detail.

Curved surfaces

Some of the blanks you chose for the earlier projects may have been slightly domed. They should not have given you any trouble, but a really curved surface such as a bowl or a bead requires a slight variation on the sifting technique.

Supporting a curved piece in the kiln must be pre-planned. You do not want to have stilt marks or to glue the piece to your trivet accidentally. Have a rehearsal first, making sure that the piece will be stable and not fall over.

Hot enamel tends to slide down the sides of a curved piece. To overcome this, reverse it top to bottom for each firing and, except for the last firing, go only to the orange peel stage. Using hard flux as a base coat is also a help.

You will need

Kiln and firing equipment
Copper bowl
Plant mister and dilute gum solution (see page 20)
Scrap paper
Hard flux and sifter
Black enamel
Transparent red and orange enamels
Heavy copper wire coil
Tweezers
Carborundum stick
Emery paper
Ceramic fibre

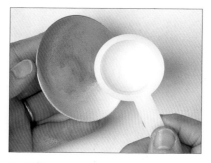

1. Clean and de-grease the inside of the bowl and mist it with gum solution. Hold the bowl over scrap paper and sift on a layer of flux. Begin with the edges; tip and turn the bowl so that the enamel always falls at right angles to the surface. This ensures an even layer. Sift the base more sparingly, as the enamel may slide when hot. Let it dry and fire it to the orange peel stage.

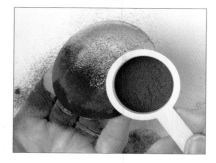

2. Clean any loose fire scale off the back and edges before misting and sifting black to counterenamel the bowl. Again, tip and turn so that the enamel falls at right angles. Give the centre of the back a small extra helping of enamel.

Tip

When misting with gum solution, hold the bowl to one side of the direction of the spray, so that it catches only light drops in an even layer.

3. Place the bowl on the trivet, black side up. Use tweezers to place the wire spiral in the centre, on top of the unfired enamel. When the enamel is dry, fire the bowl until the wire spiral sinks into the enamel. Cool the bowl and clean the edges.

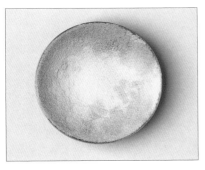

4. Sift transparent red enamel on the edge and sides of the bowl's inside, then transparent orange over the rest. Place the bowl on the trivet right side up. Dry and fire it until it is just smooth and shiny. Red enamel needs a lower temperature than other colours: no more than 800°C (1472°F). Clean and level the surface of the wire spiral with either a carborundum stick or a metal file, then polish it with emery paper to make a smooth base for the bowl.

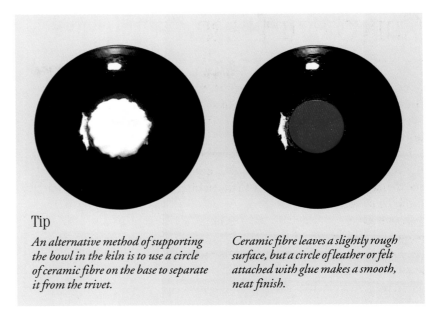

Tip

An alternative method of supporting the bowl in the kiln is to use a circle of ceramic fibre on the base to separate it from the trivet.

Ceramic fibre leaves a slightly rough surface, but a circle of leather or felt attached with glue makes a smooth, neat finish.

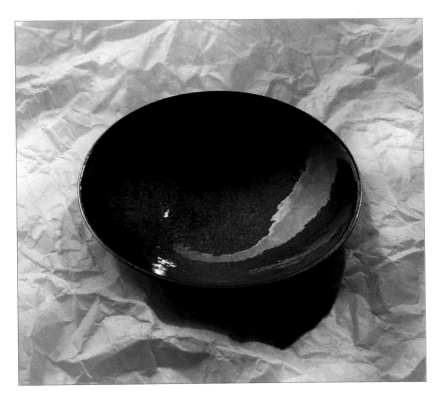

The finished bowl. Two similar colours or two shades of the same colour give a more lively appearance than one. Decorative lumps or chips of enamel could be placed in the centre before the last firing. With a little thought and planning, many of the other techniques in this book can be used on bowls.

Raku firing and silver lustre

Raku firing produces beautiful, randomly coloured lustres on enamel. The technique is borrowed from pottery and adapted to suit the more rapid cooling time of enamel.

Lustre and colours are produced by burning away all the oxygen around the enamel as soon as it comes out of the kiln, so that it cools in a 'reducing' atmosphere. The results are not very controllable but it is great fun to experiment, with the added element of surprise at the end.

Only flux and transparent enamels will lustre, but opaque enamel can be used in areas where you do not want lustre. By using very thin layers of transparent enamel, in this case flux, copper oxide is drawn into the enamel and colours it. Other colours can come from the organic material used to burn off the oxygen. I used newspaper for the first piece and dead leaves for the second.

Raku firing requires split-second timing and great care must be taken to achieve it safely. It is essential to have a rehearsal while everything is cold, and have a bucket of water ready when using flammable materials as an extra safety measure.

Using damp newspaper

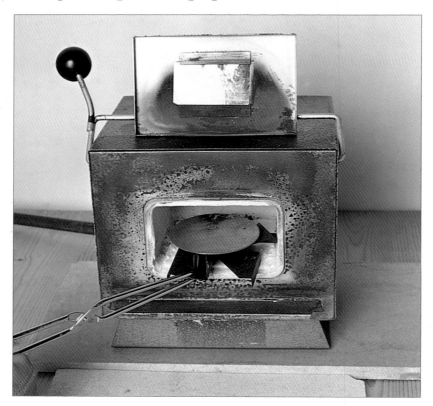

1. Have the newspaper and heat-proof surface right beside the kiln and the bucket of water close by. As part of your rehearsal, use tongs to put your piece (in this case a coaster) in to the unheated kiln on a stilt.

2. Put on the gloves and practise taking the coaster out safely, holding the stilt with tongs. Drop the coaster face down onto the damp newspaper and quickly put the stilt in a safe place (remember it will be hot when you actually do this).

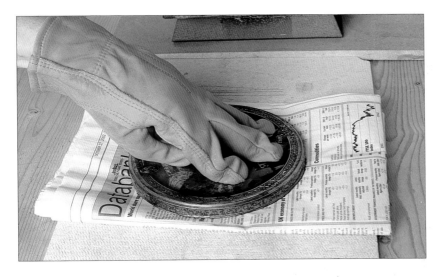

3. Practise clamping the biscuit tin lid over the coaster as soon as you can after it lands on the newspaper. The next time you do this everything will be hot, there will be smoke and the lid must go on before you get actual flames. Practice will give you confidence; when you do the real thing you will have the bucket of water in case of accident.

4. Set your kiln for about 900°C (1652°F). Clean and de-grease the coaster, then mist it with gum solution and sift on a very thin layer of flux. Let it dry and then draw a spiral design with your finger. Tip off the surplus enamel and fire the piece in a hot kiln. Allow it to cool, brush off any loose fire scale and sift another thin layer of flux all over. Fire the piece again; cool and clean it, then counterenamel it. If it warps, now is the time to flatten it (see Troubleshooting on page 63).

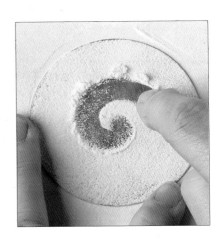

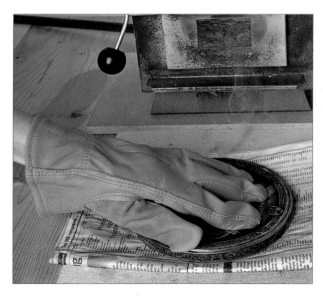

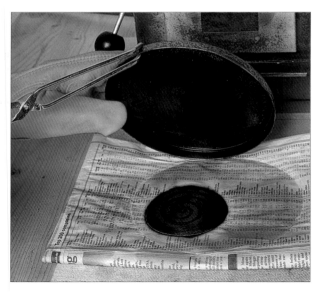

5. Place the coaster on the stilt, right side up and re-fire it until it is very hot. Dampen the newspaper with a wet hand. As you practised before, drop the hot coaster face down on the slightly damp newspaper and clamp the tin lid over it to trap the smoke and prevent air getting in. The side of the piece that touches the newspaper first usually gets the best lustre.

6. Hold the lid in place for a few minutes, just until the smoke stops pouring out. Then use your tongs to lift the lid and turn the coaster over. It needs some air at this point to allow colours to develop. When it is cool, wash it clean and see what you have. If the colours are not interesting, you can repeat steps 5 and 6 with a fresh newspaper. Sometimes two or even three attempts are needed.

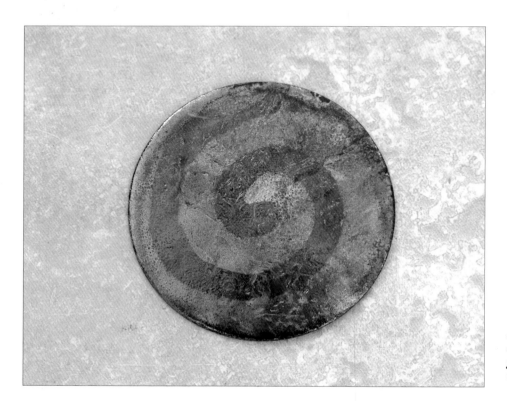

The finished coaster. Note how the colours vary from dark blues at one edge to reds, greens and copper lustre in the centre.

Using dead leaves

All kinds of organic material can be used for raku firing. It must be dry and, if possible, freshly gathered. The best colours come from newly dead material that has not been exposed to rain. The surface of the enamel will be textured by the leaves, but any sharp edges can be smoothed with a carborundum stick or a piece of emery paper.

I used a shallow copper bowl for this piece with a wire spiral on its base to stop it sticking to the trivet.

You will need

As for 'using damp newspaper', but also:
Dead leaves
Metal container
Pre-enamelled and counterenamelled shallow copper bowl

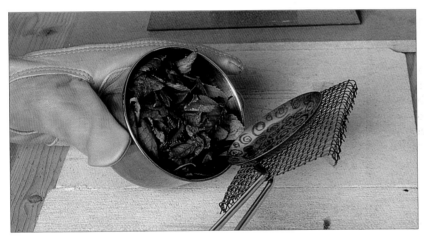

1. Put the leaves into a metal container; large enough for your piece to enter easily, but not so large that it holds too much air. Allow about 5cm (2in) in all directions. If your container is too large, fill the unwanted space with sand. Mist the top layer very lightly with water. Enamel and fire your piece as before and deposit it face down in the container of leaves.

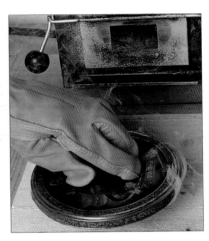

2. Clamp the tin lid down over the smoking container and continue as for the coaster.

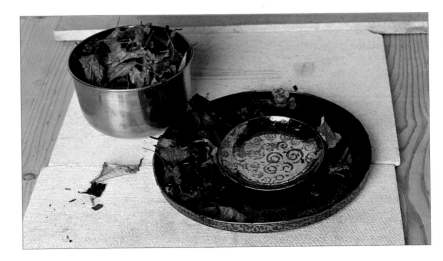

3. The larger the piece, the longer you leave it in the container. Here the bowl is cooling after two full minutes in the container of leaves.

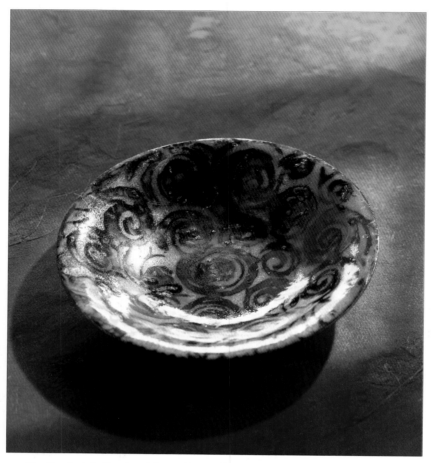

The finished shallow bowl. Liquid enamel was used for the first coat so that a more detailed design could be drawn. The second coat was ordinary powdered flux. Drawing very detailed patterns is a waste of effort as they tend to blur with each firing.

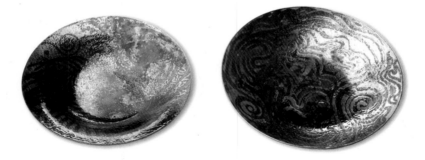

It is possible to get different colours from the dead organic materials. The bowl on the left has quite a lot of red from hawthorn leaves, while the one on the right has a golden tone from the trimmings of lavender bushes. Experiment – you never know what surprises you may get.

Silver lustre on copper

Silver lustre can be produced on copper by painting on various mixtures containing silver nitrate (or silver carbonate) before raku firing.

When making and using the mixtures, always wear old clothes and rubber or latex gloves, which you should wash before you remove them. It is essential to work in a well-ventilated place and avoid breathing in the poisonous fumes when the silver nitrate mixture is fired. Protect your work surfaces as silver nitrate stains everything a permanent dark brown. Store the mixtures in black film canisters in a cool place; exposure to light will ruin them. In a refrigerator they can last for up to six months.

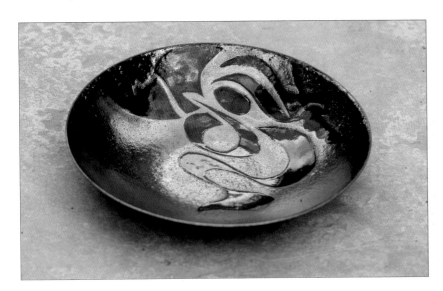

Silver and red bowl

The whole bowl was enamelled with transparent black over hard flux. Then a masking film stencil was applied and the following mixture painted on. Recipe: Dissolve a few crystals (about ¼ teaspoon) of silver nitrate in about a tablespoonful of distilled water. Add enough of this to a tablespoonful of liquid white enamel to make a pale grey. This mixture is best the day after it is made. Adding silver nitrate to liquid enamel tends to make the mixture thick. Thin it with distilled water. The proper consistency depends on the effect you want and your method of application. The bowl was allowed to dry before the masking film was removed, then it was raku fired using damp newspaper.

Paisley patterned tile

One crystal of silver nitrate was dissolved in half a film canister of distilled water and painted thinly over the whole of the tile, which had been pre-enamelled with flux like the coaster. It was allowed to dry and then raku fired. The colours of the raku shine through a silvery haze.

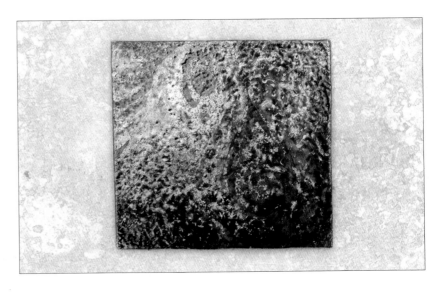

Firing beads

You can enamel large, hollow copper beads to make striking and individual jewellery. A bead is just a more extreme type of curved surface. Once it has a coat of enamel, you can decorate it using many of the techniques in this book.

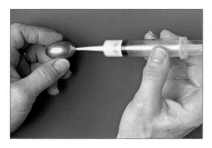

1. Use a glue syringe to fill the bead with some liquid enamel. Roll the bead about until you think you have coated the inside all over. Let any excess drip out on to a tissue. This has the effect of counterenamelling. Leave it to dry overnight.

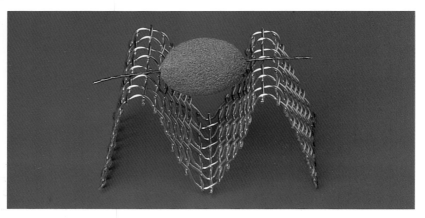

2. You need to work out how to hold a bead while applying the enamel. I use a piece of flat stainless steel wire (from a dental supplier) pushed through the holes in the bead; this allows me to turn it without damaging the unfired enamel. The same wire supports it across an 'M' shaped trivet in the kiln and is removed with a twist after firing. Apply dilute gum solution with a brush and sift on the enamel, keeping the sifter at right angles to the surface of the bead. Work quickly before the gum solution dries. Wipe the wire clean and place it across the trivet. Dry and fire as usual.

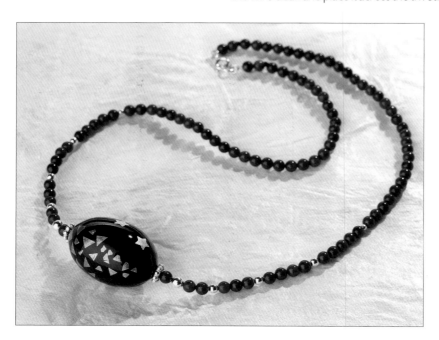

Gold foil was used to decorate this bead. Light-weight decorative items are best as heavy pieces may slide round during firing.

Troubleshooting

Even experienced enamellers encounter problems from time to time. If you have a problem, first check that every stage was done correctly. Was the copper really clean and de-greased; is your enamel clean; did you counterenamel; was the enamel dry when it went into the kiln? What about the thickness of the enamel and the temperature of the kiln? You can often identify the cause of a problem in this way.

The white oval has an unintentional green patch due to the enamel being too thin and fired a little too long. To cure this, apply another layer of white enamel.

The opposite applies to this red/white square. The enamel is too thick, was not fired quite long enough and has chipped off. The cure is to rub off the red and thin the white undercoat, using a carborundum stick and water, before reapplying the red.

All attempts to melt the central light brown lump when swirling this black pendant failed because it was very hard enamel, not suitable for this technique. The greenish halo round the purple and at the end of the pendant show it was fired at a very high temperature.

Some colours, particularly red, do not like too much heat, and this hoop has been over-fired. Another coat of enamel may cover the blackness; but if the enamel is already quite thick, it should be rubbed down first. Fire again at a lower temperature.

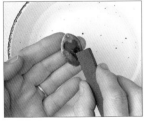

Removing bubbles from enamel

Air bubbles are not uncommon and a second, slightly hotter, firing may remove them. The green heart from the Wet laying enamel project on page 44 developed a large bubble. It was rubbed with carborundum stick and water to break the surface, then glass brushed with clean water. The hole was filled with enamel and re-fired. Doing this may result in a bump on the surface, so rub it down flat and fire again.

Flattening warped pieces

Copper and enamel are soft enough to reshape at the moment they come out of the kiln. Pressing lightly between two smooth steel or iron surfaces will flatten a warped piece, and the enamel will not stick to these metals. A steel block, heavy stainless steel tray, or the bottom of an old iron saucepan are some of the items that can be used. The raku coaster warped and had to be flattened before the final firing. It was reheated, then tipped quickly onto the flat base of a stainless steel bowl and an old flat iron was laid on top immediately.

Index

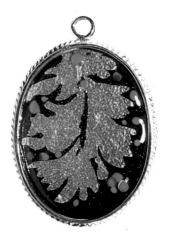